Prow 50 Famous Faces

BOOKS IN THIS SERIES

Draw 50 Airplanes, Aircraft, and Spacecraft Draw 50 Animals Draw 50 Athletes Draw 50 Beasties and Yugglies and Turnover Uglies and Things That Go Bump in the Night Draw 50 Boats, Ships, Trucks, and Trains Draw 50 Buildings and Other Structures Draw 50 Cars, Trucks, and Motorcycles Draw 50 Cats Draw 50 Creepy Crawlies Draw 50 Dinosaurs and Other Prehistoric Animals Draw 50 Dogs Draw 50 Endangered Animals Draw 50 Famous Caricatures Draw 50 Famous Cartoons Draw 50 Famous Faces Draw 50 Flowers, Trees, and Other Plants Draw 50 Holiday Decorations Draw 50 Horses Draw 50 Monsters, Creeps, Superheroes, Demons, Dragons, Nerds, Dirts, Ghouls, Giants, Vampires, Zombies, and Other Curiosa . . . Draw 50 People Draw 50 People of the Bible Draw 50 Sharks, Whales, and Other Sea Creatures Draw 50 Vehicles

Druu 50

Famous Faces

LEE J. AMES

Doubleday

New York London Toronto Sydney Auckland

A Main Street Book PUBLISHED BY DOUBLEDAY a division of Bantam Doubleday Dell Publishing Group, Inc. 1540 Broadway, New York, New York 10036

MAIN STREET BOOKS, DOUBLEDAY, and the portrayal of a building with a tree are trademarks of Doubleday, a division of Bantam Doubleday Dell Publishing Group, Inc.

ISBN: 0-385-23432-5 Paperback

Copyright © 1978 by Lee J. Ames All Rights Reserved Printed in the United States of America

Library of Congress Cataloging-in-Publication Data Ames, Lee J. Draw 50 famous faces. 1. Face in art. 2. Drawing—Technique.

3. Biography—Portraits. I. Title.

NC770.A46 743'.49 77-15878

20 19 18 17 16 15 14 13 12 11

To Betsy

Many thanks to Holly Moylan for all her help.

, •

To the Reader

This book will show you a way to draw faces. You need not start with the first illustration. Choose whichever you wish. When you have decided, follow the step-by-step method shown. *Very lightly* and *carefully*, sketch out the step number one. However, this step, which seems the easiest, should be done *most carefully*. Step number two is added right to step number one, also lightly and also very carefully. Step number three is sketched right on top of numbers one and two. Continue this way to the last step.

It may seem strange to ask you to be extra careful when you are drawing what seem to be the easiest first steps, but this is most important, for a careless mistake at the beginning may spoil the whole picture at the end. As you sketch out each step, watch the spaces between the lines, as well as the lines, and see that they are the same. After each step, you may want to lighten your work by pressing it with a kneaded eraser (available at art supply stores).

When you have finished, you may want to reinforce the final step in India ink with a fine brush or pen. When the ink is dry, use the kneaded eraser to clean off the pencil lines. The eraser will not affect the India ink.

Here are some suggestions: In the first few steps, even when all seems quite correct, you might do well to hold your work up to a mirror. Sometimes the mirror shows that you've twisted the drawing off to one side without being aware of it. At first you may find it difficult to draw the egg shapes, or ball shapes, or sausage shapes, or just to make the pencil go where you wish. Don't be discouraged. The more you practice, the more you will develop control.

In drawing these portraits I made extensive use of photographs. Most professional illustrators do use photographic help. Some artists may "remember" sufficient details of an occasional face to enable them to create a reasonable resemblance. But this happens rarely and is never as successful as when a model or photograph is used.

The only equipment you'll need will be a medium or soft pencil, paper, the kneaded eraser and, if you wish, a compass, pen or brush.

The first steps in this book are shown darker than necessary so that they can be clearly seen. (Keep your work very light.)

Remember there are many other ways and methods to make drawings. This book shows just one method. Why don't you seek out other ways from teachers, from libraries and, most importantly...from inside yourself?

To the Parent or Teacher

"David can draw Abraham Lincoln better than anybody else!" Such peer acclaim and encouragement generate incentive. Contemporary methods of art instruction (freedom of expression, experimentation, self-evaluation of competence and growth) provide a vigorous, fresh-air approach for which we must all be grateful.

New ideas need not, however, totally exclude the old. One such is the "follow me, step-by-step" approach. In my young learning days this method was so common, and frequently so exclusive, that the student became nothing more than a pantographic extension of the teacher. In those days it was excessively overworked.

This does not mean that the young hand is never to be guided. Rather, specific guiding is fundamental. Step-by-step guiding that produces satisfactory results is valuable even when the means of accomplishment are not fully understood by the student.

The novice with a musical instrument is frequently taught to play simple melodies as quickly as possible, well before he learns the most elemental scratchings at the surface of music theory. The resultant self-satisfaction, pride in accomplishment, can be a significant means of providing motivation. And all from mimicking an instructor's "Do-as-I-do...."

Mimicry is prerequisite for developing creativity. We learn the use of our tools by mimicry. Then we can use those tools for creativity. To this end I would offer the budding artist the opportunity to memorize or mimic (rotelike, if you wish) the making of "pictures." "Pictures" he has been eager to be able to draw.

The use of this book should be available to anyone who wants to try another way of flapping his wings. Perhaps he will then get off the ground when his friend says, "David can draw Abraham Lincoln better than anybody else!"

Lee J. Ames

Draw 50 Famous Faces

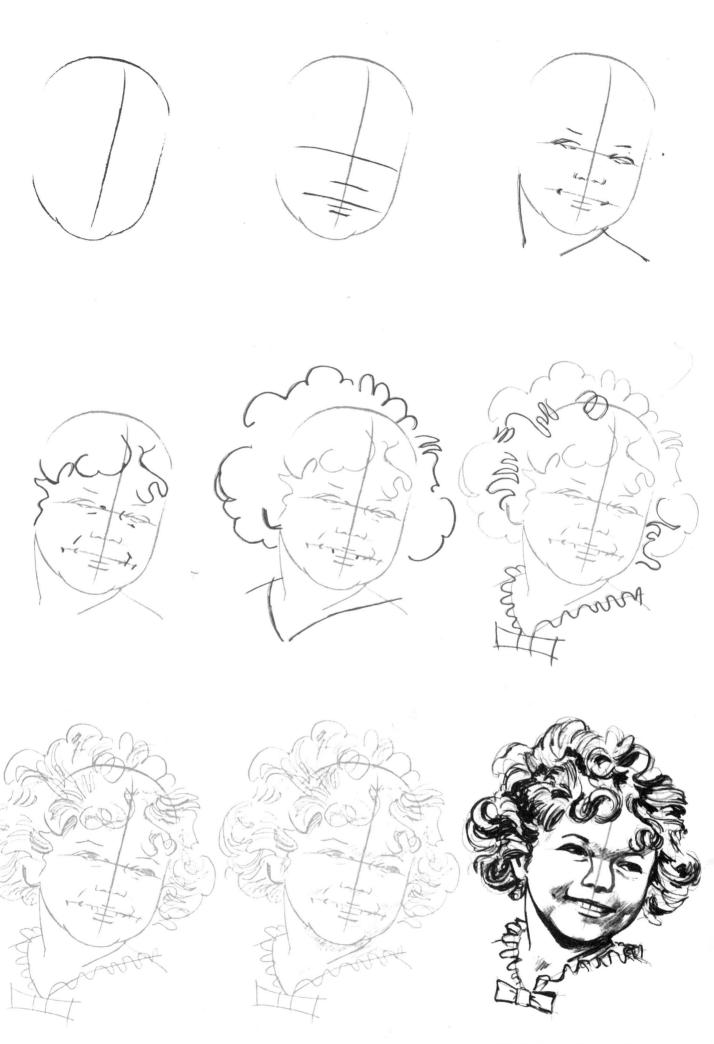

Shirley Temple

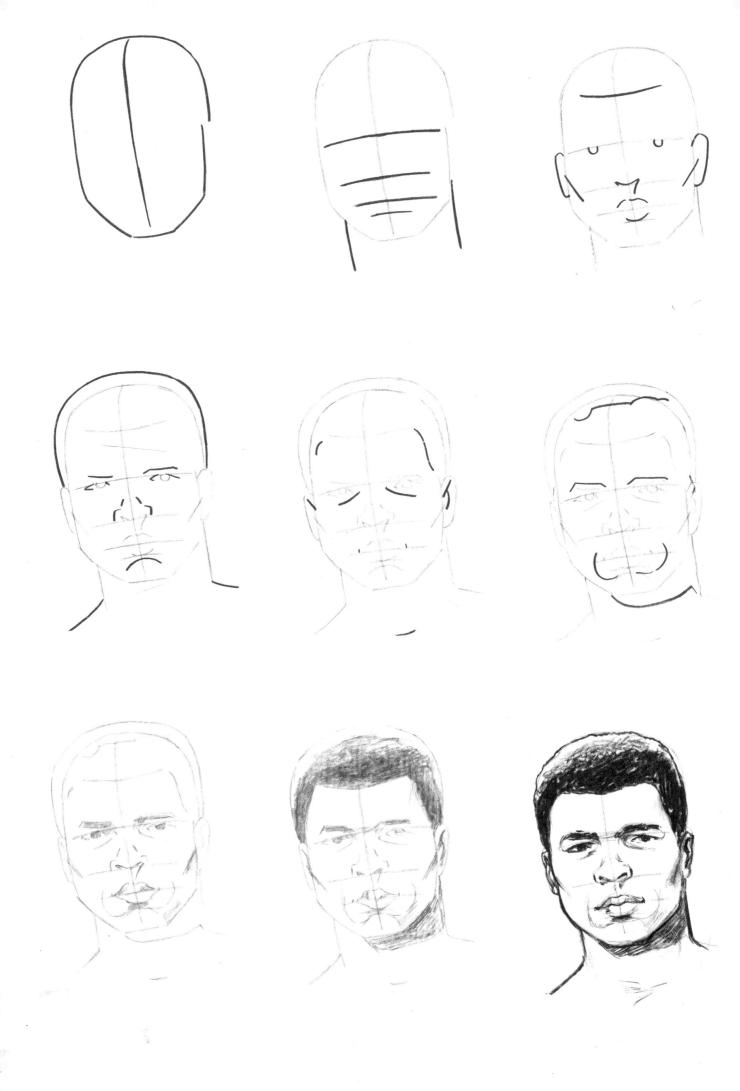

Muhammad Ali

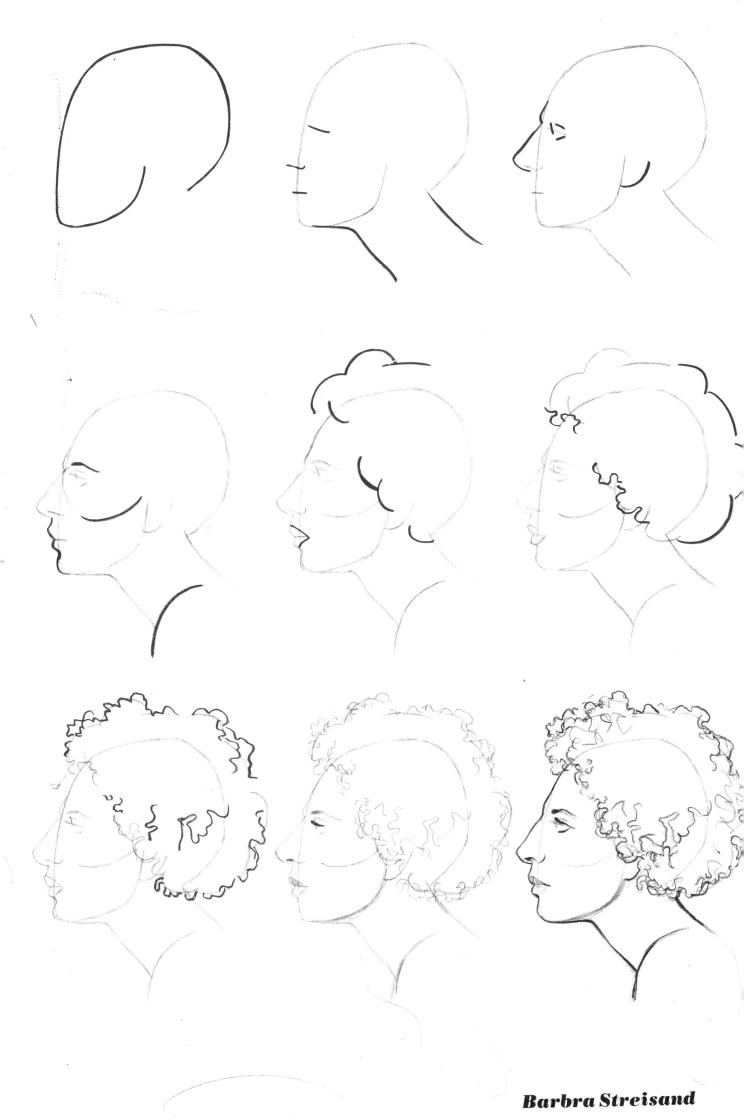

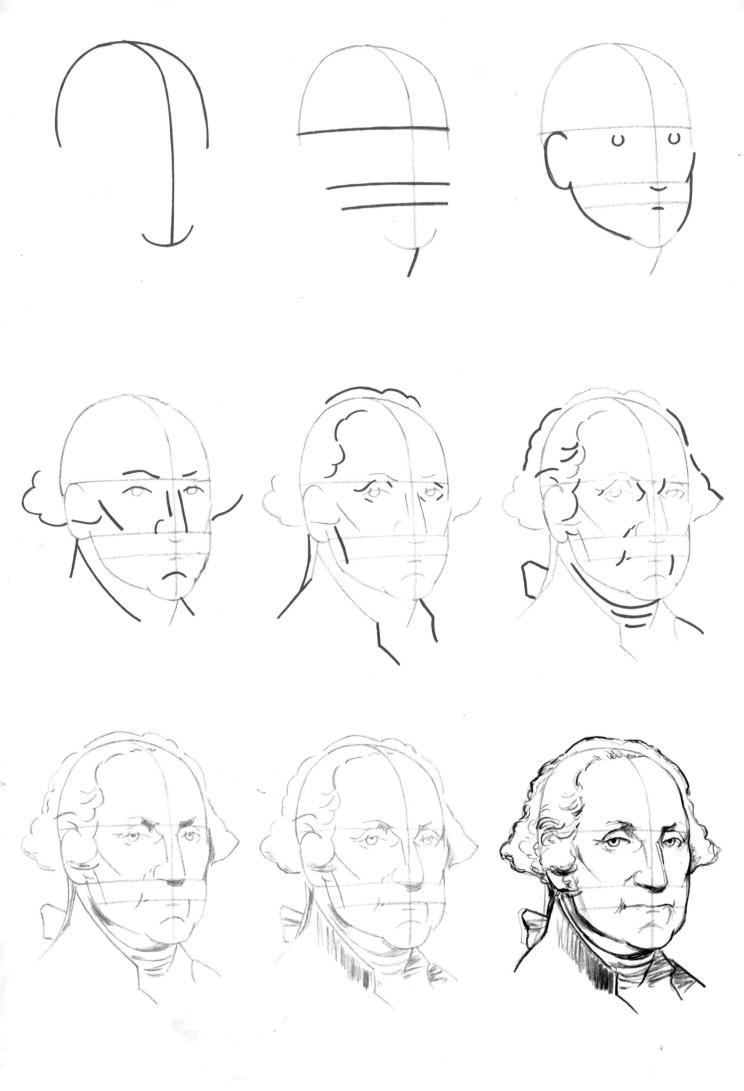

George Washington

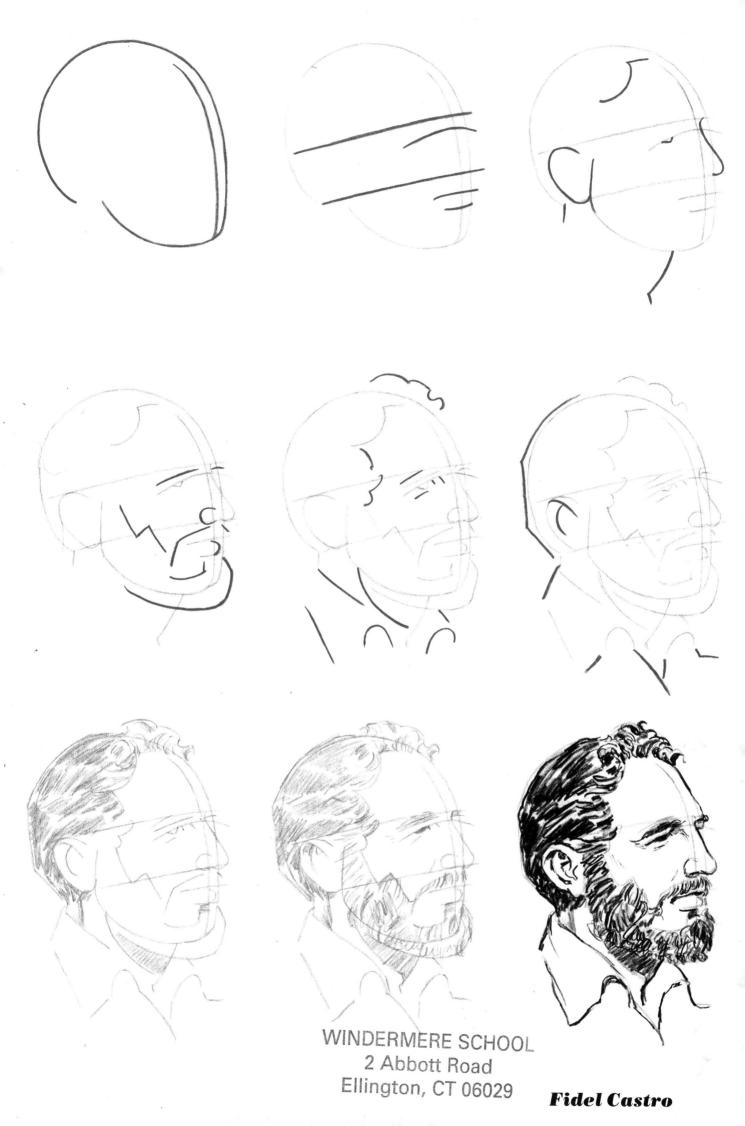

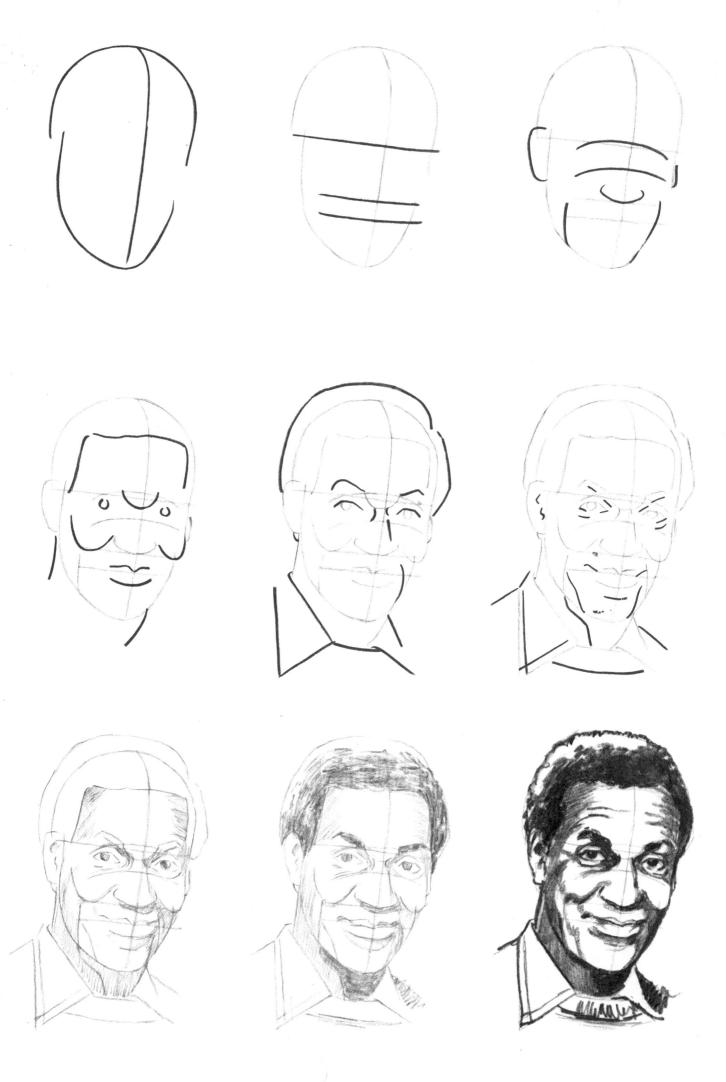

Bill Cosby

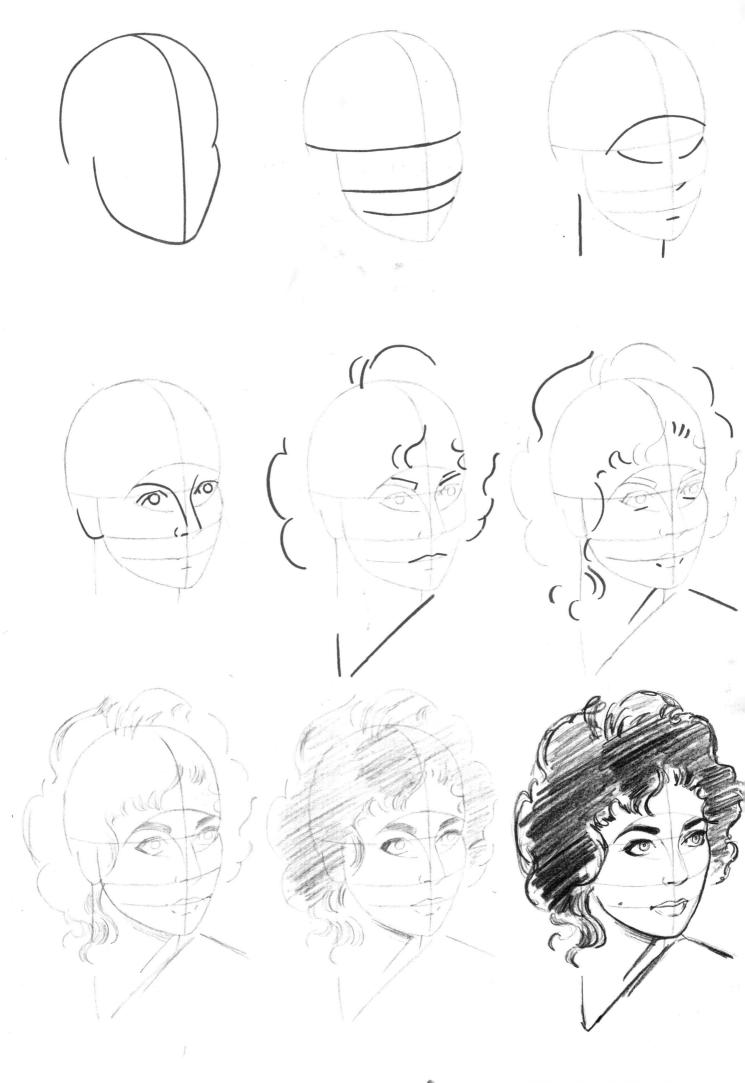

Elizabeth Taylor

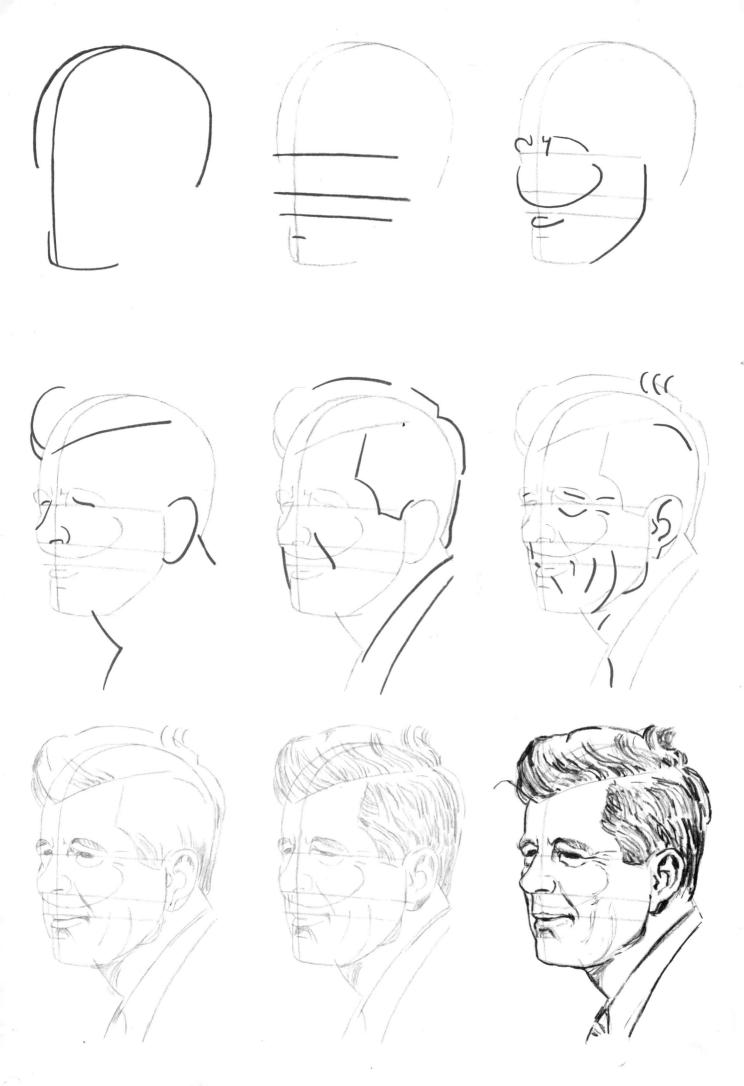

John F. Kennedy

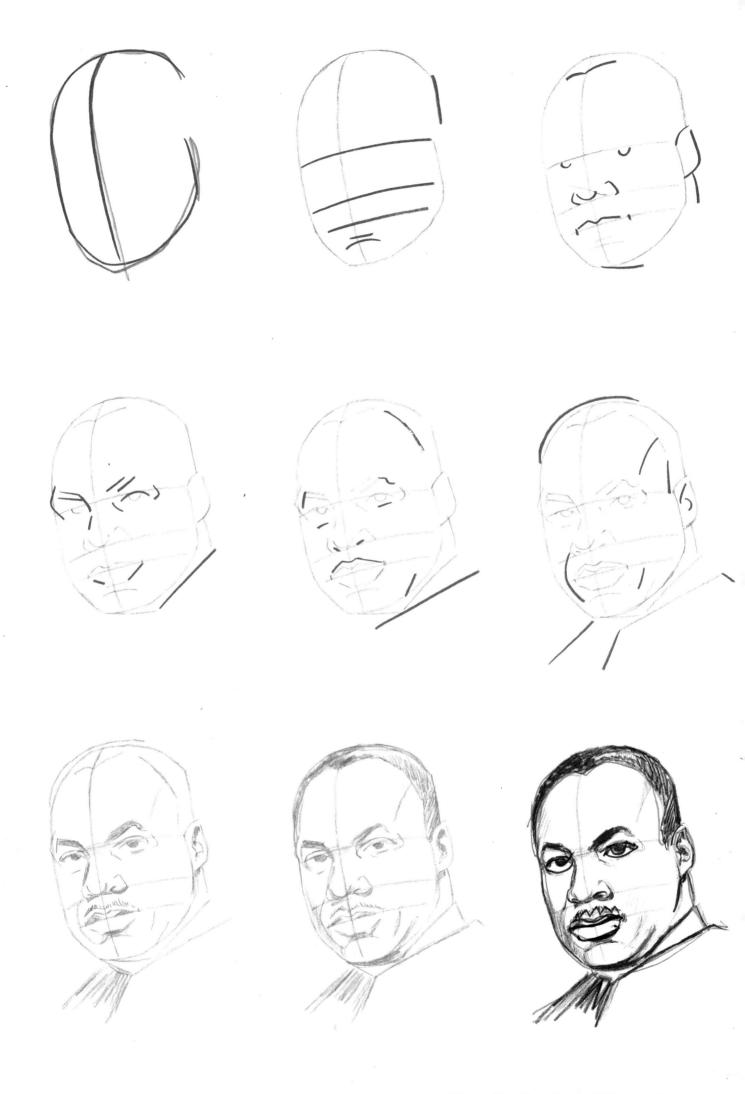

Martin Luther King, Jr.

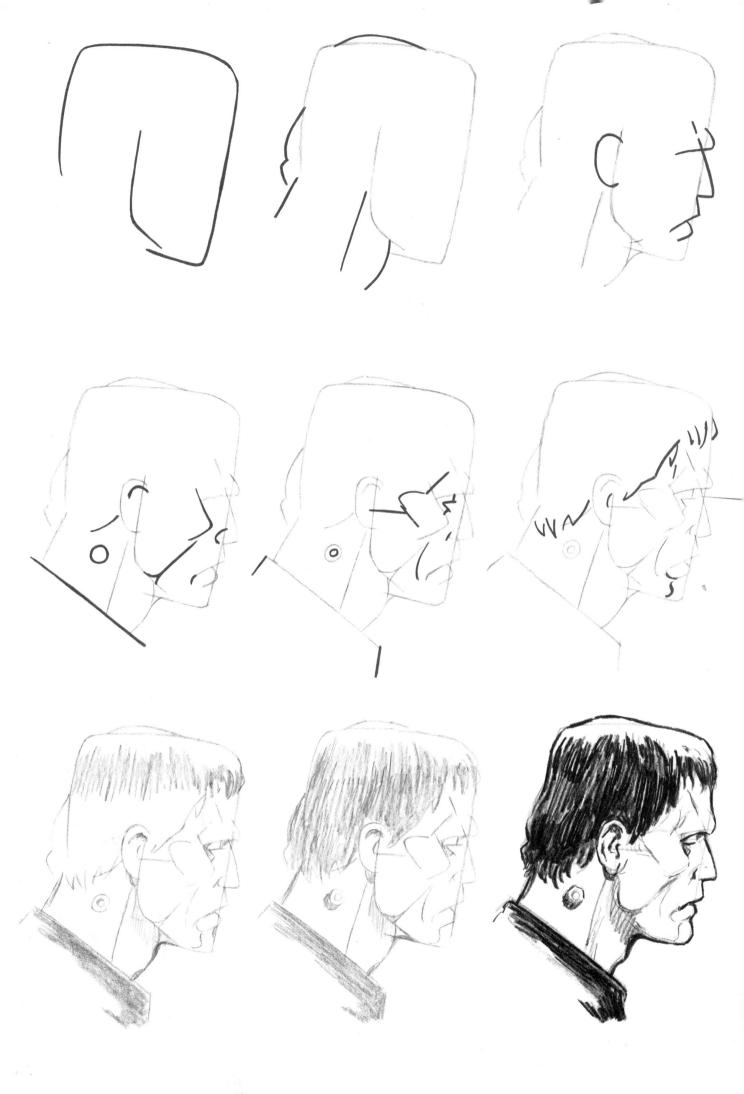

Boris Karloff as Frankenstein's Monster

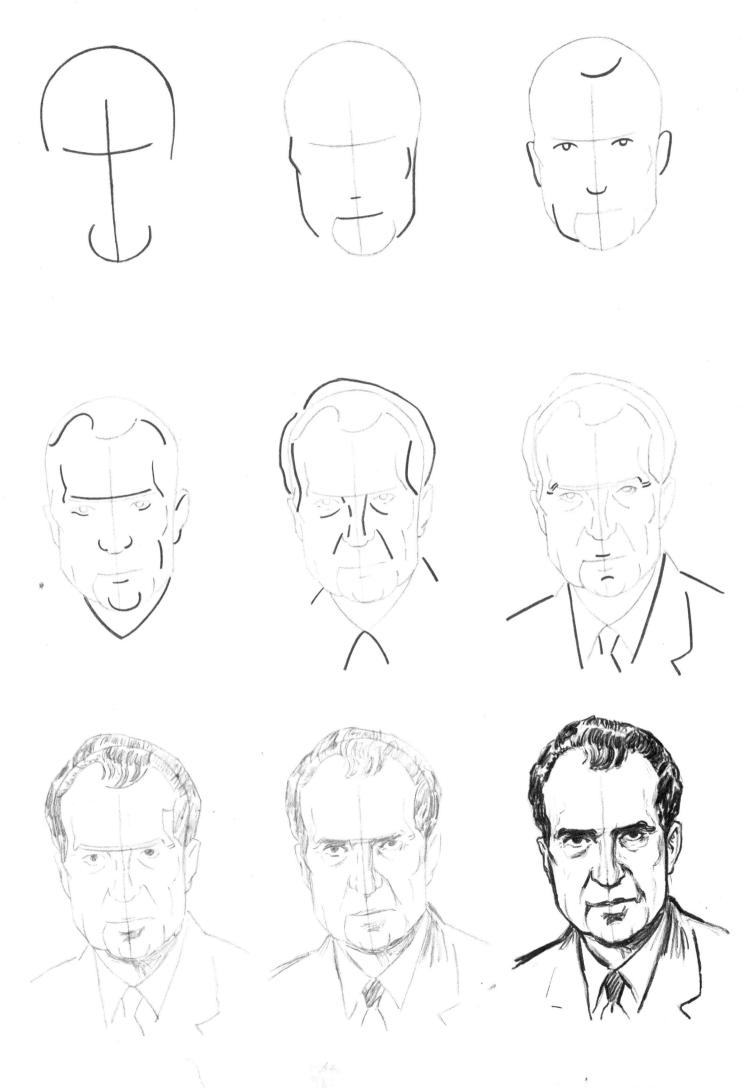

Richard M. Nixon

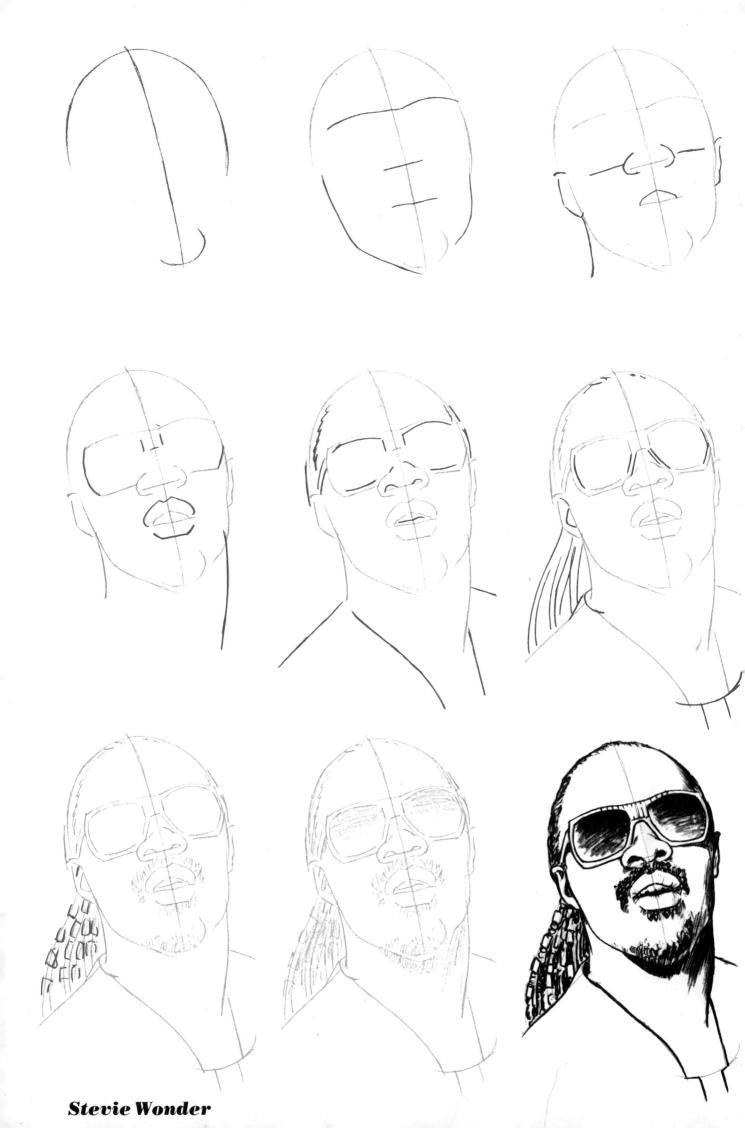

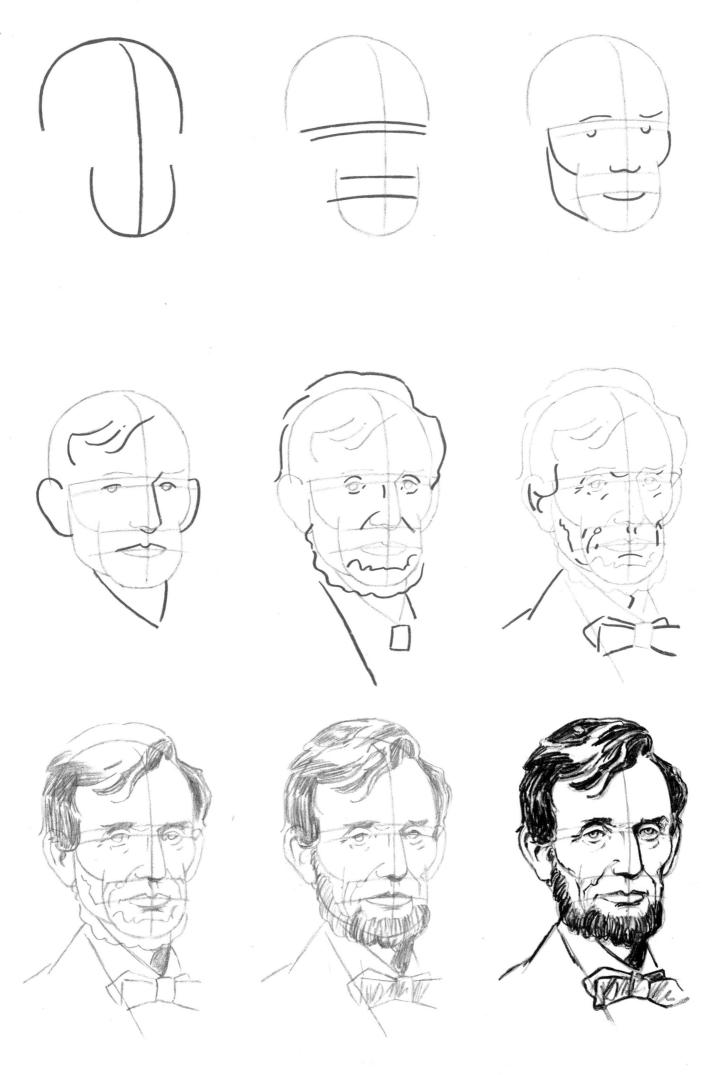

Abraham Lincoln

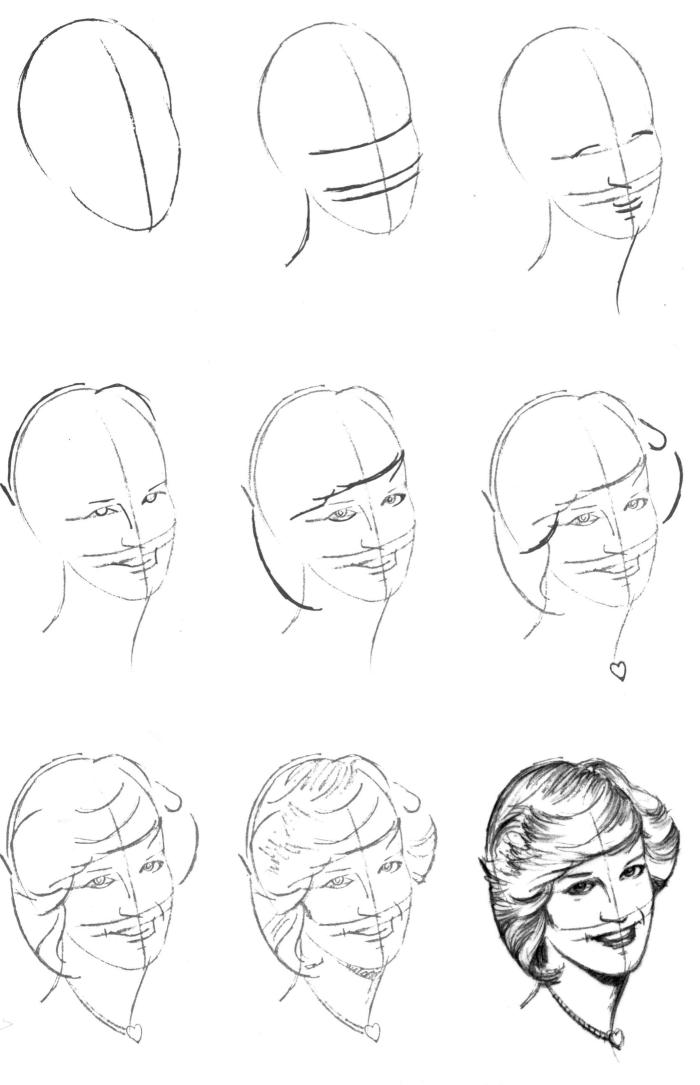

Princess Diana of Wales

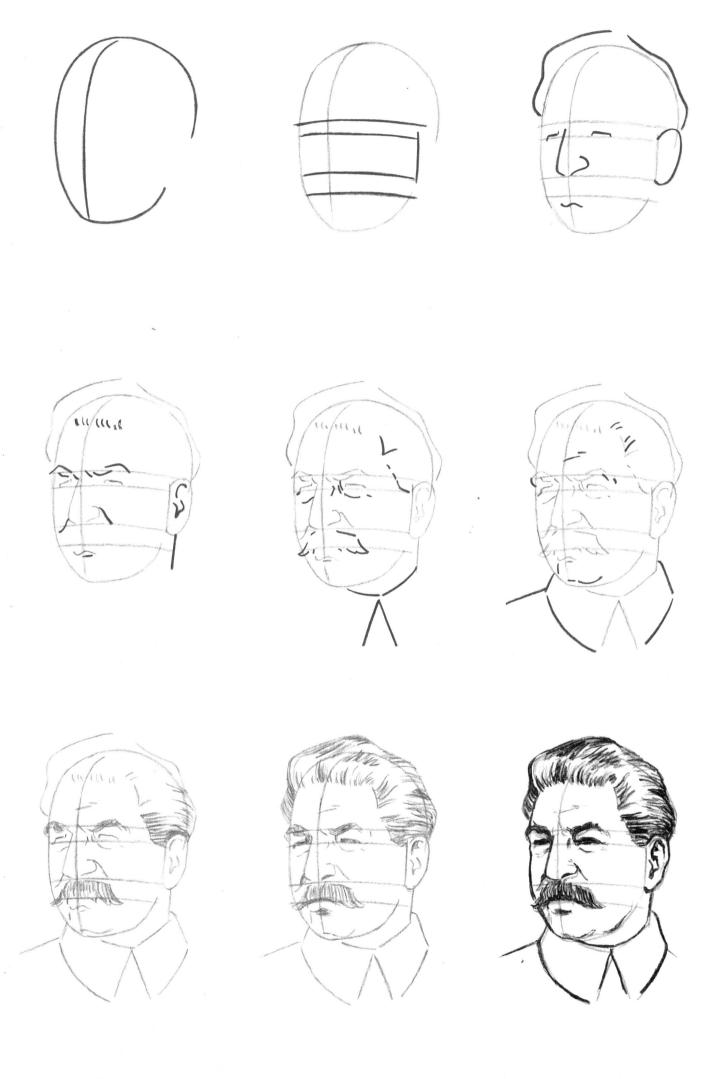

Joseph Stalin

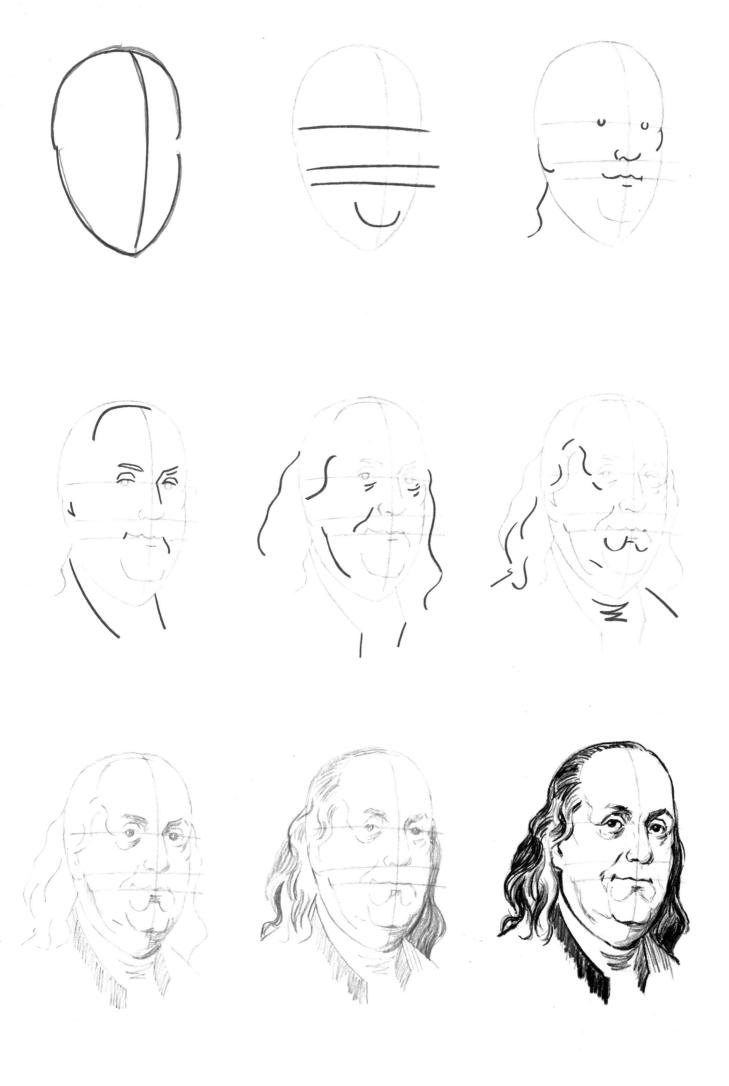

Benjamin Franklin

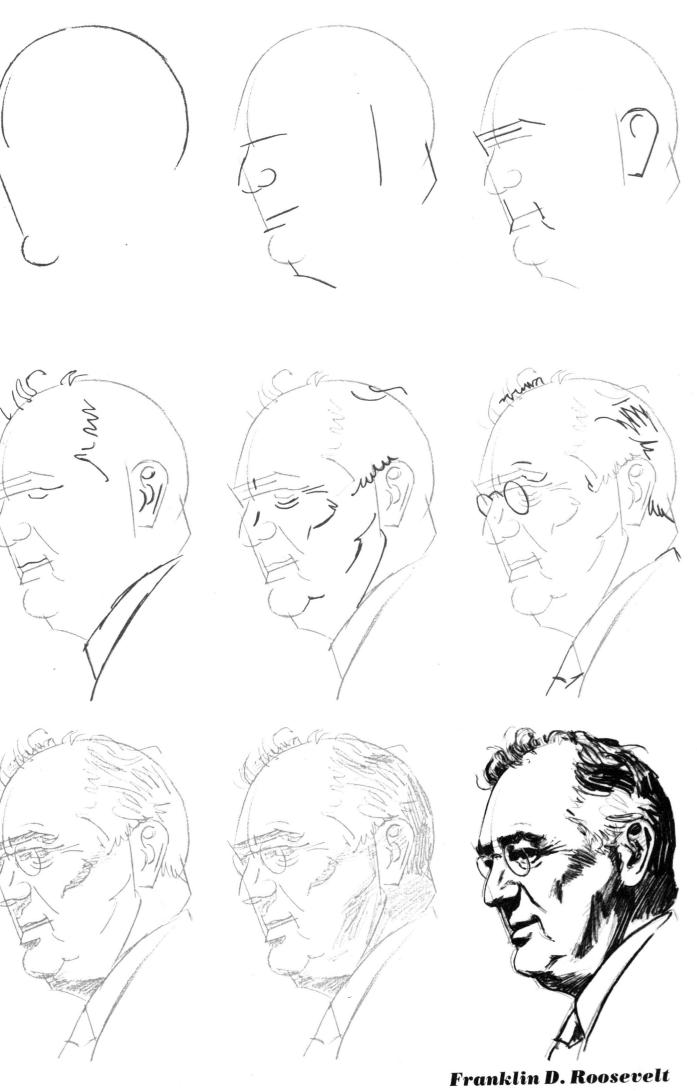

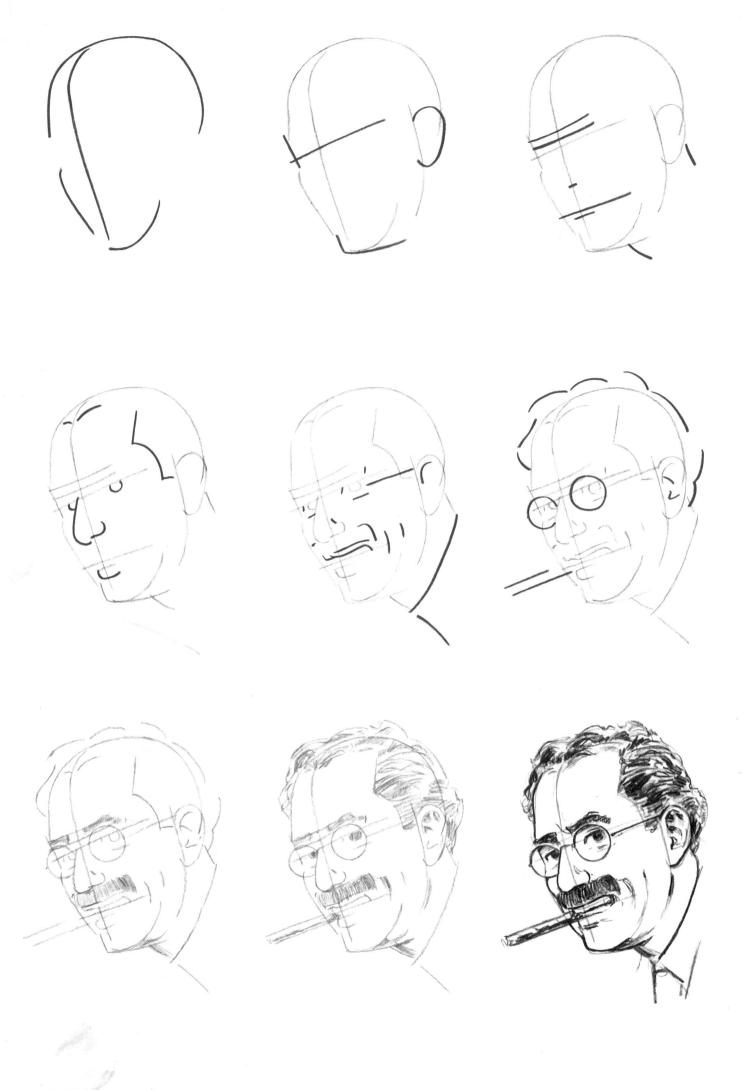

Groucho Marx

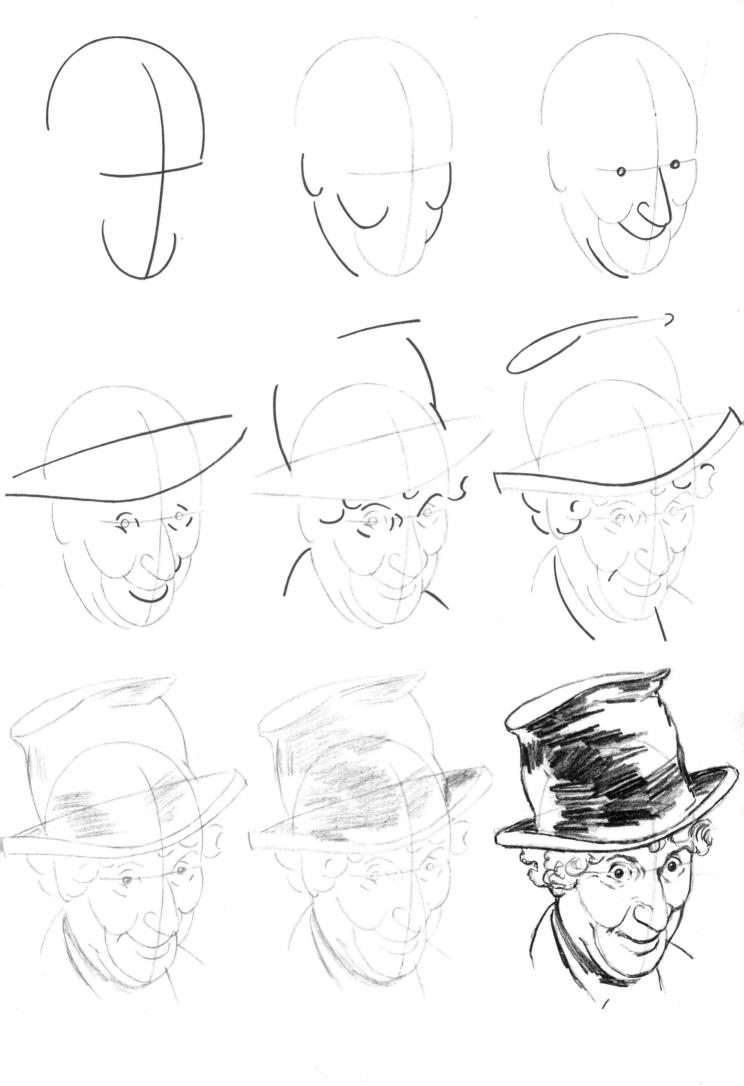

Harpo Marx

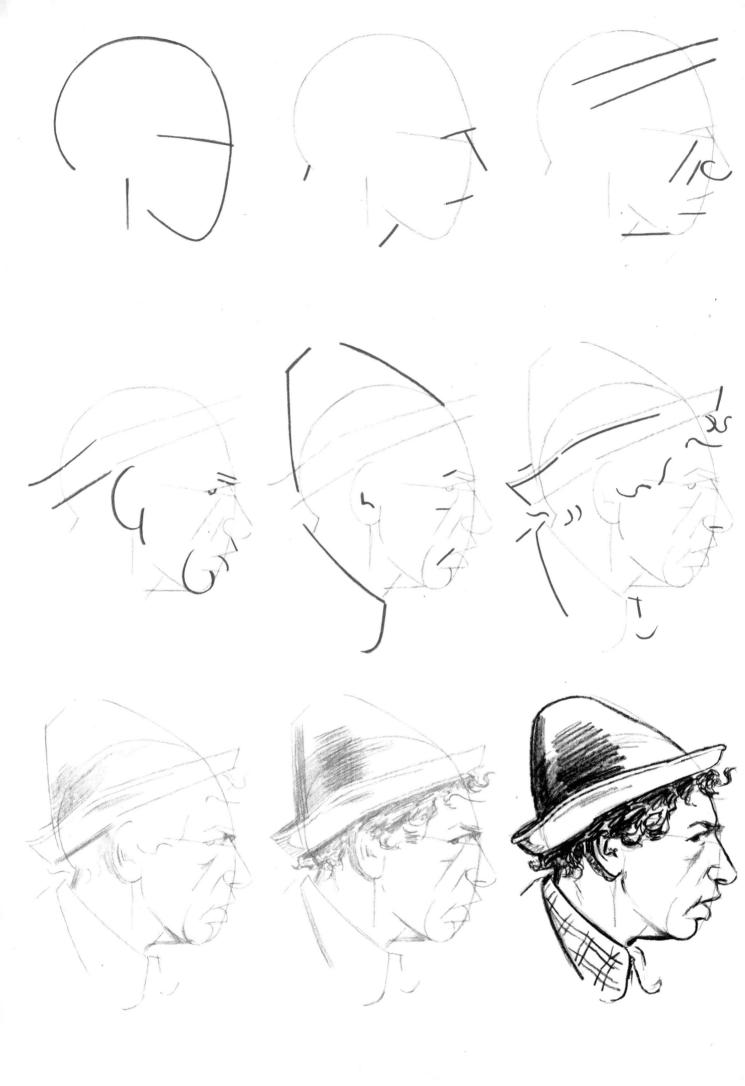

Chico Marx

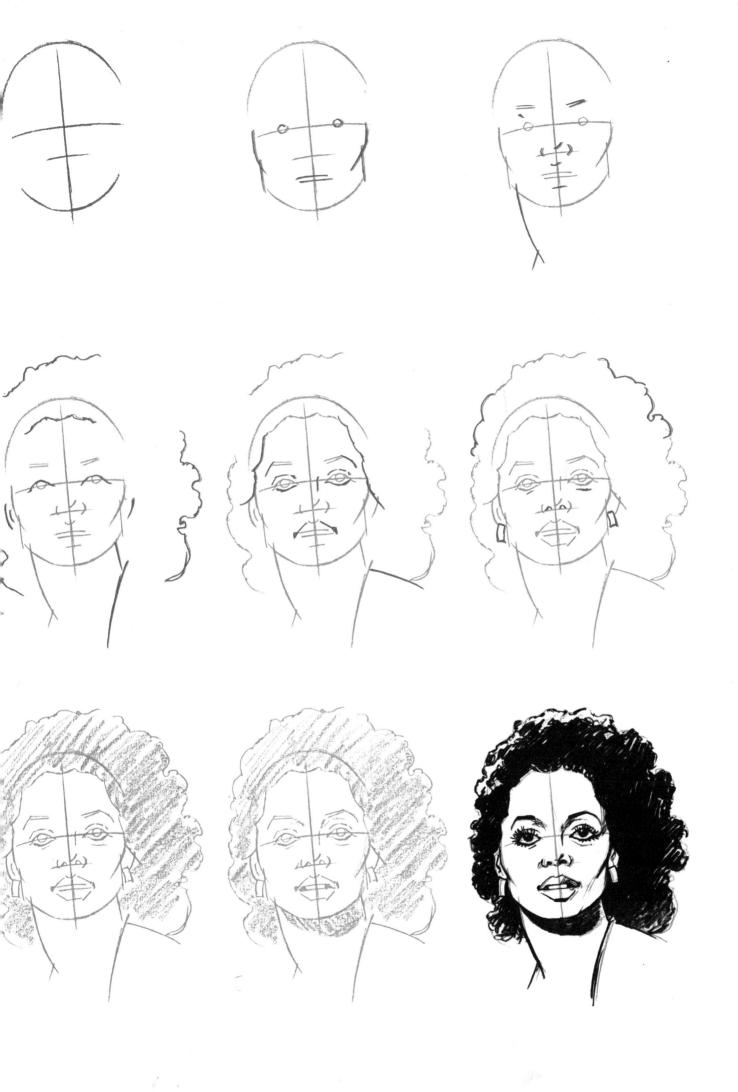

Diana Ross

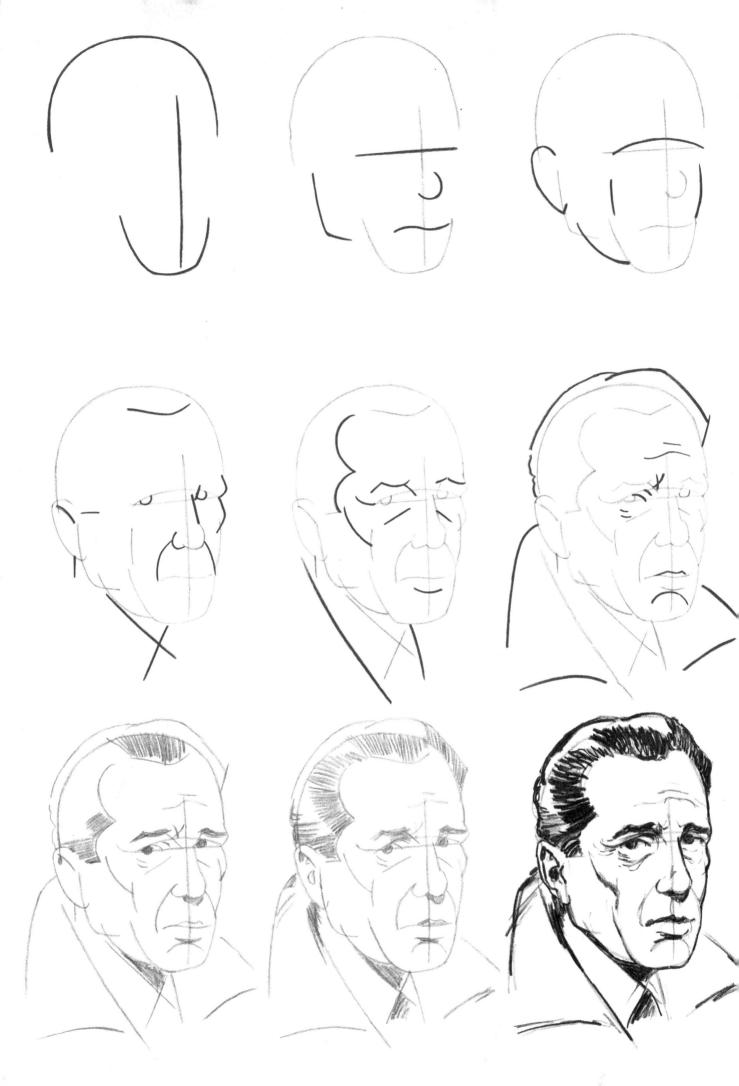

Humphrey Bogart

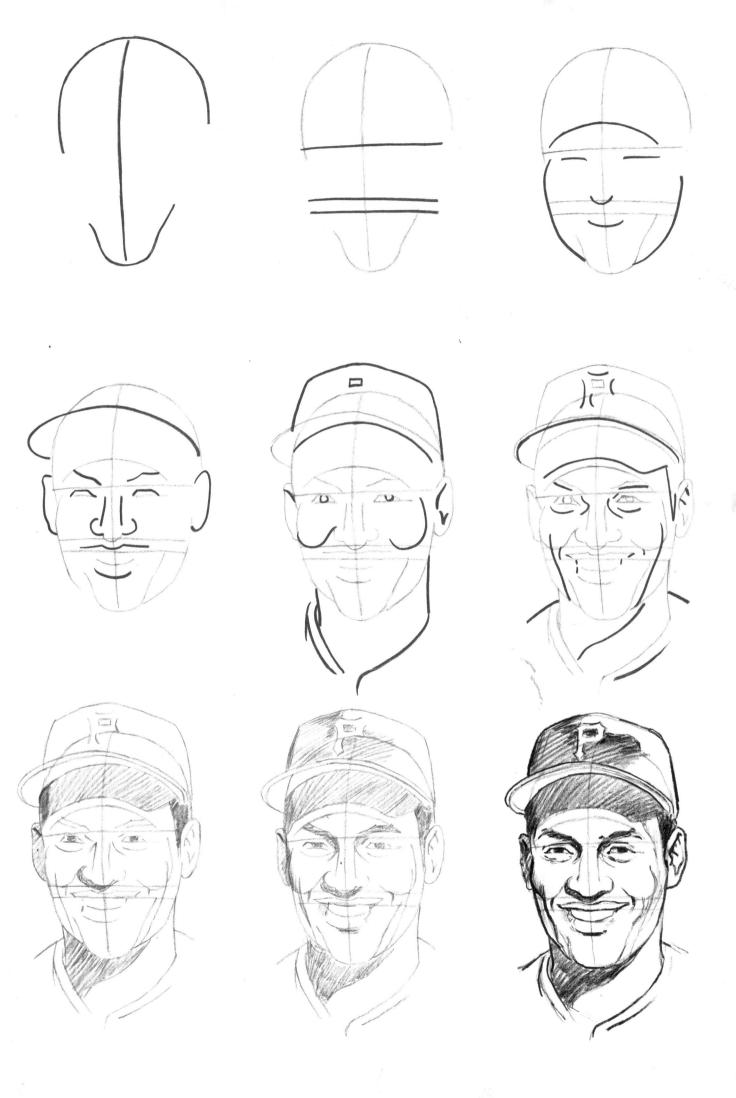

Roberto Clemente

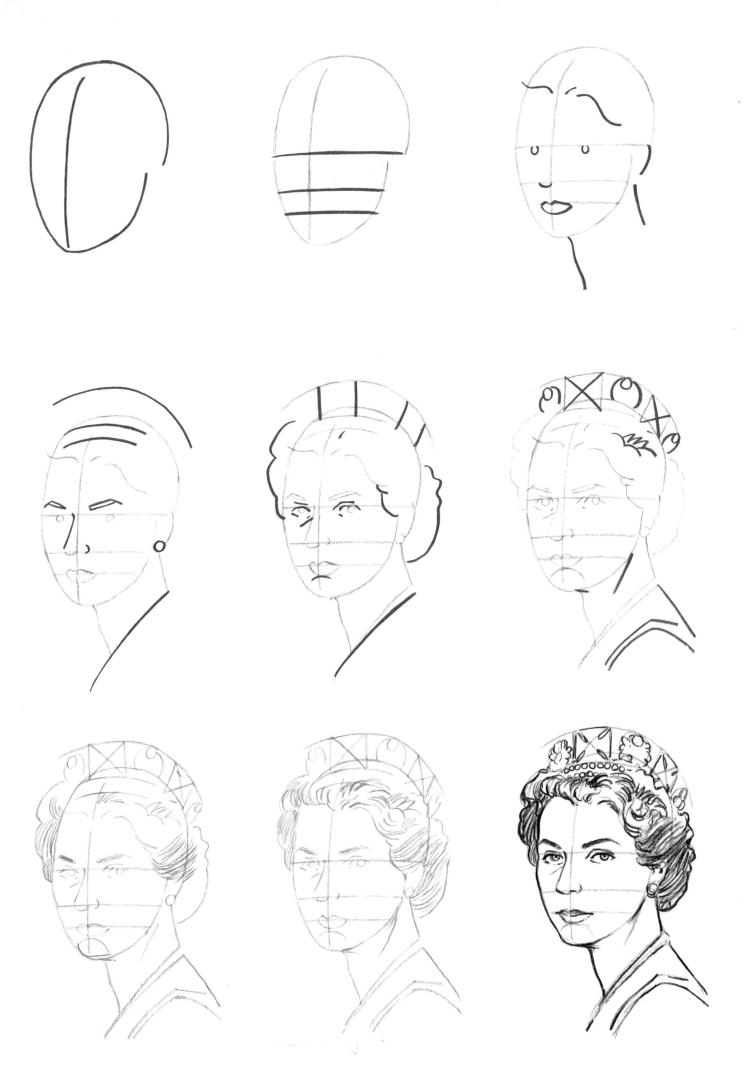

Queen Elizabeth II

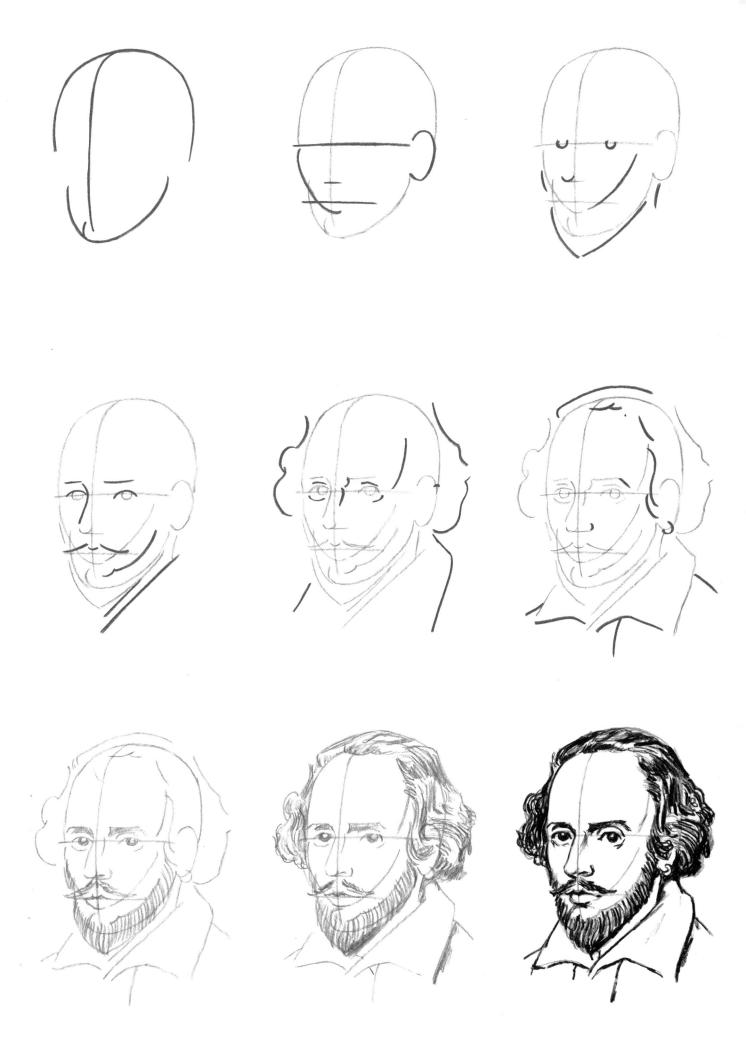

William Shakespeare

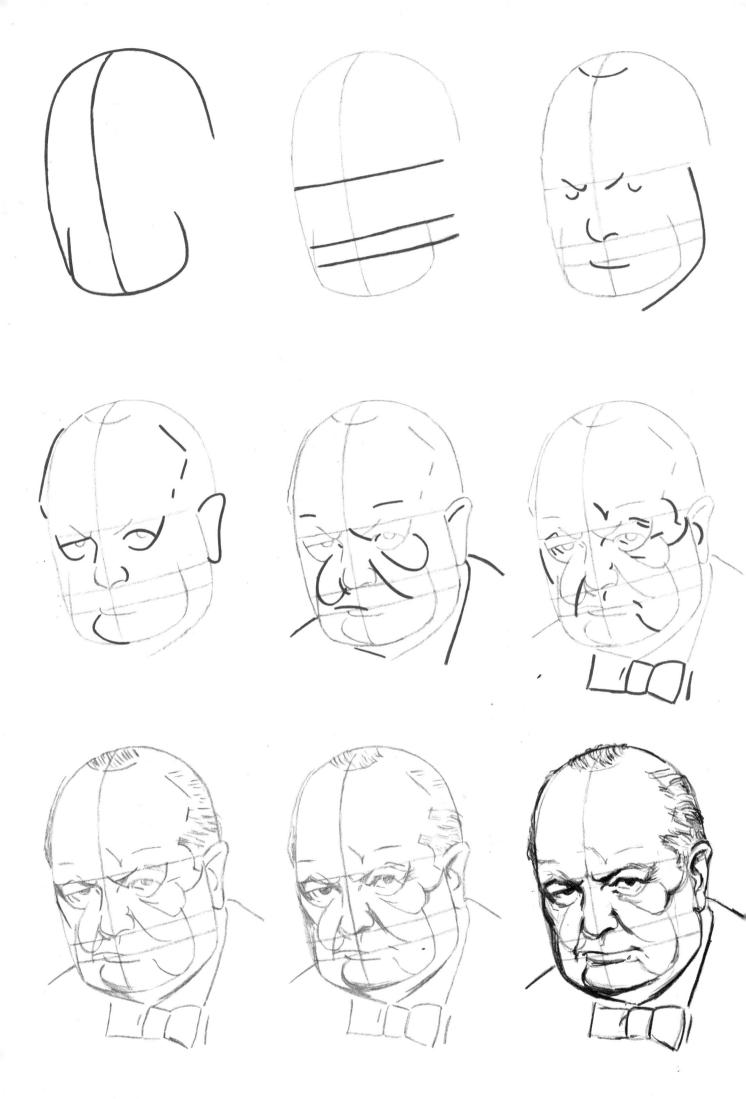

Winston Churchill

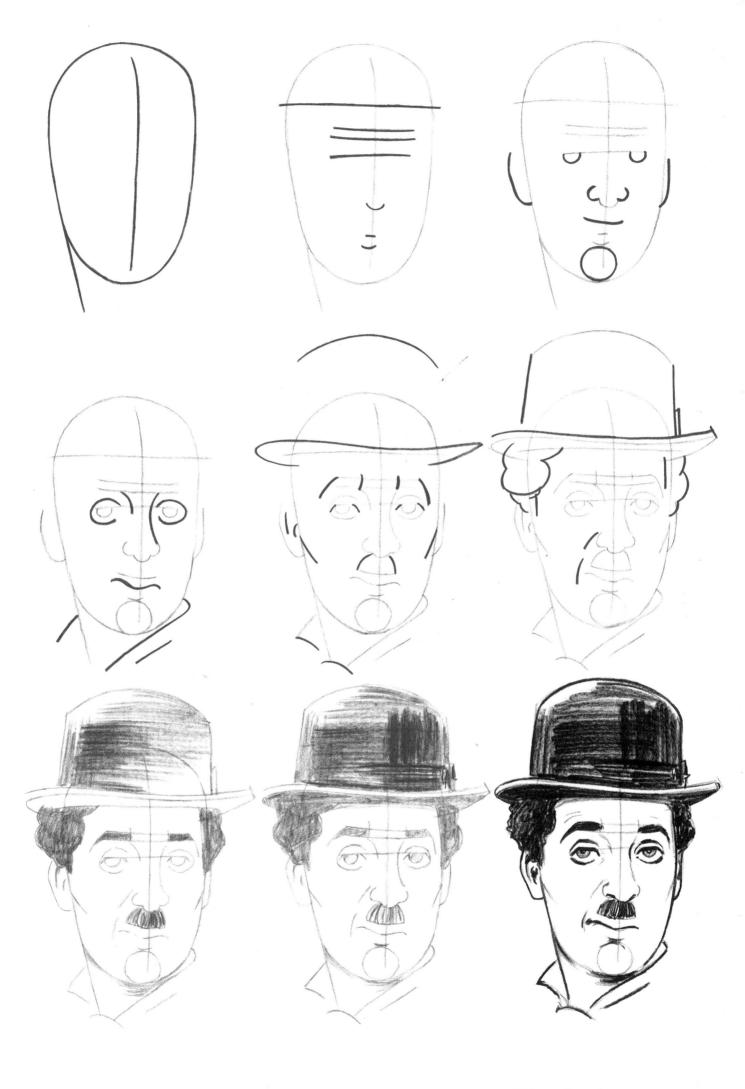

Charlie Chaplin

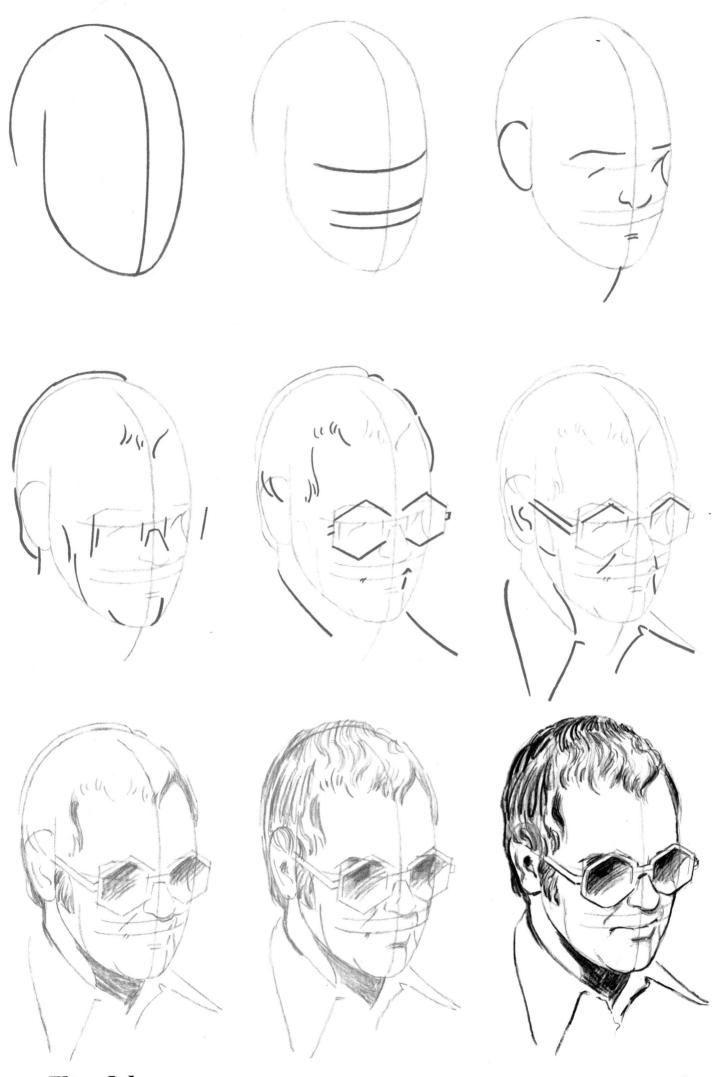

Elton John

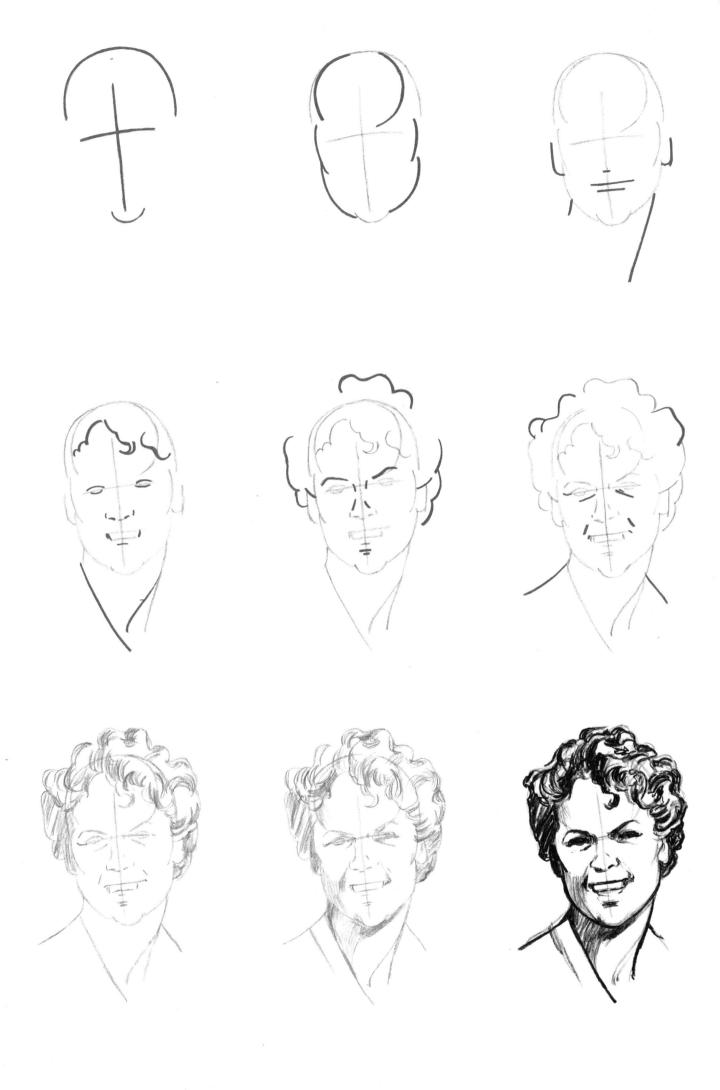

Evonne Goolagong

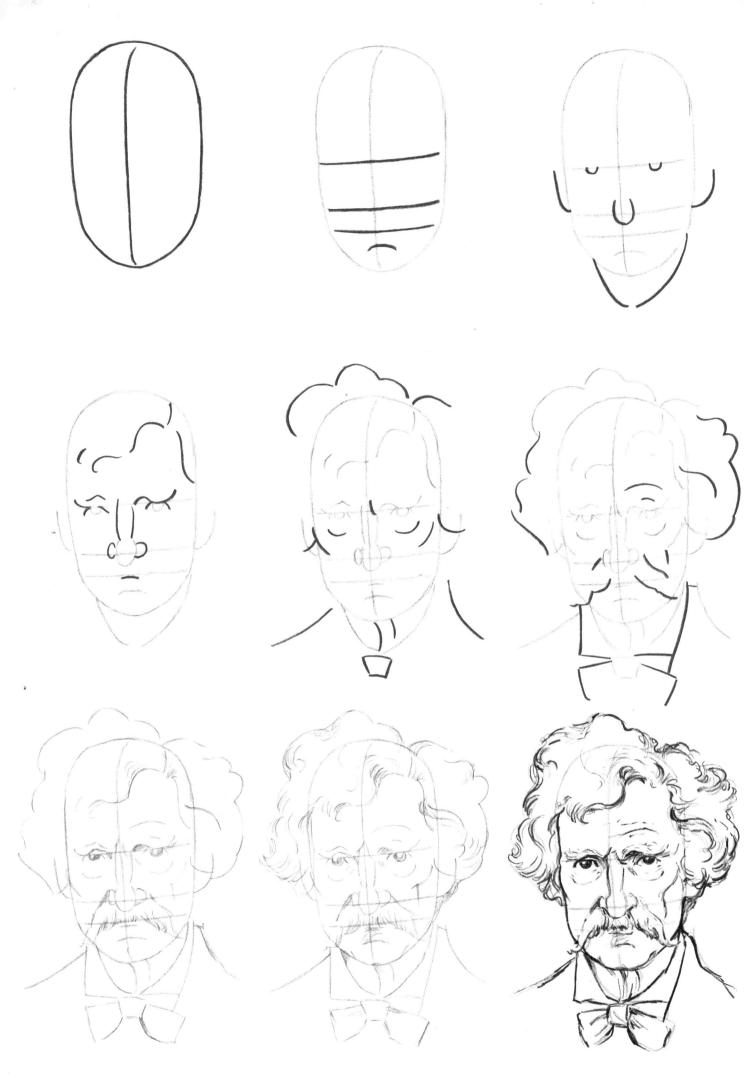

Mark Twain

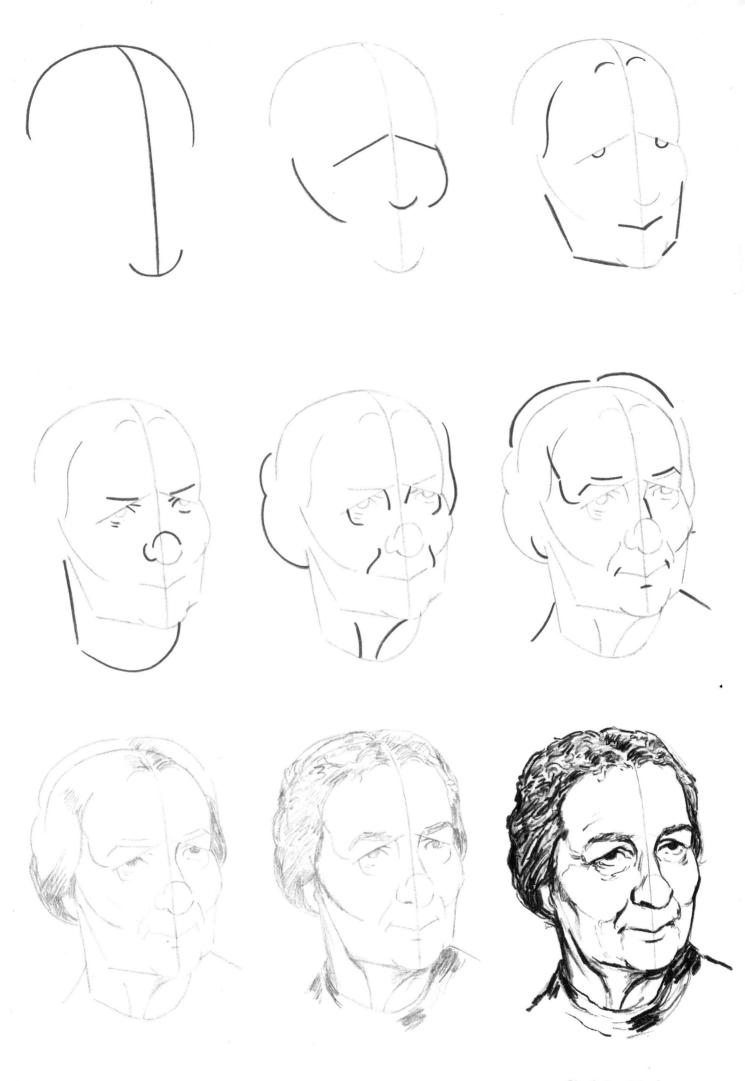

Golda Meir

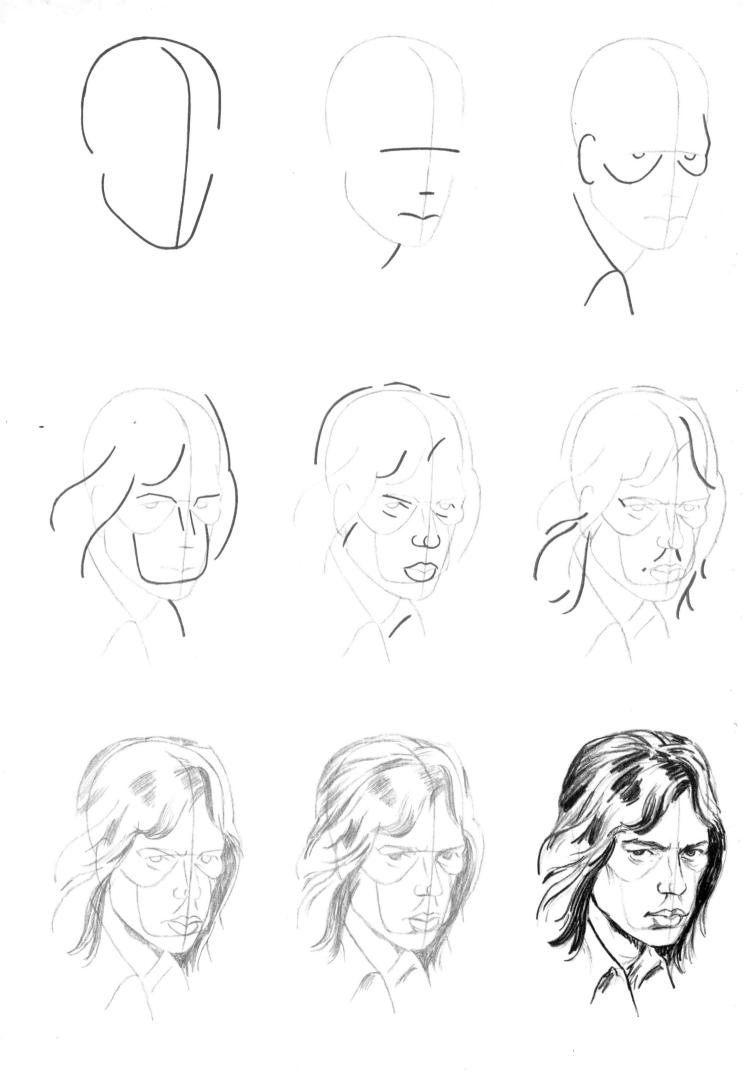

Mick Jagger

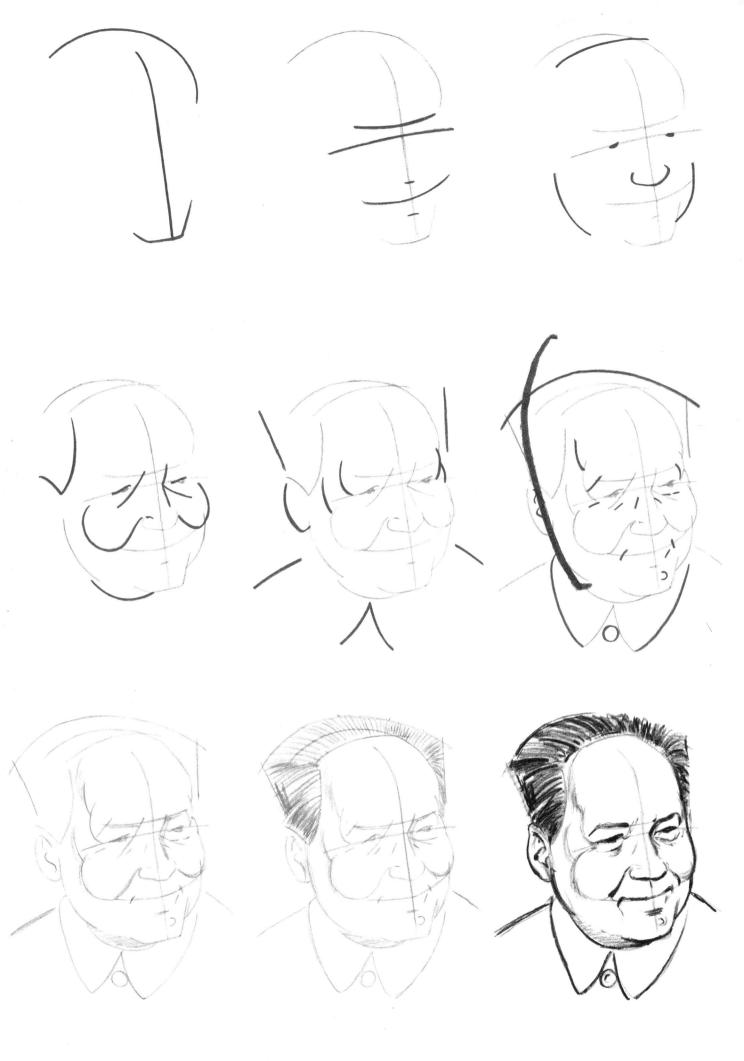

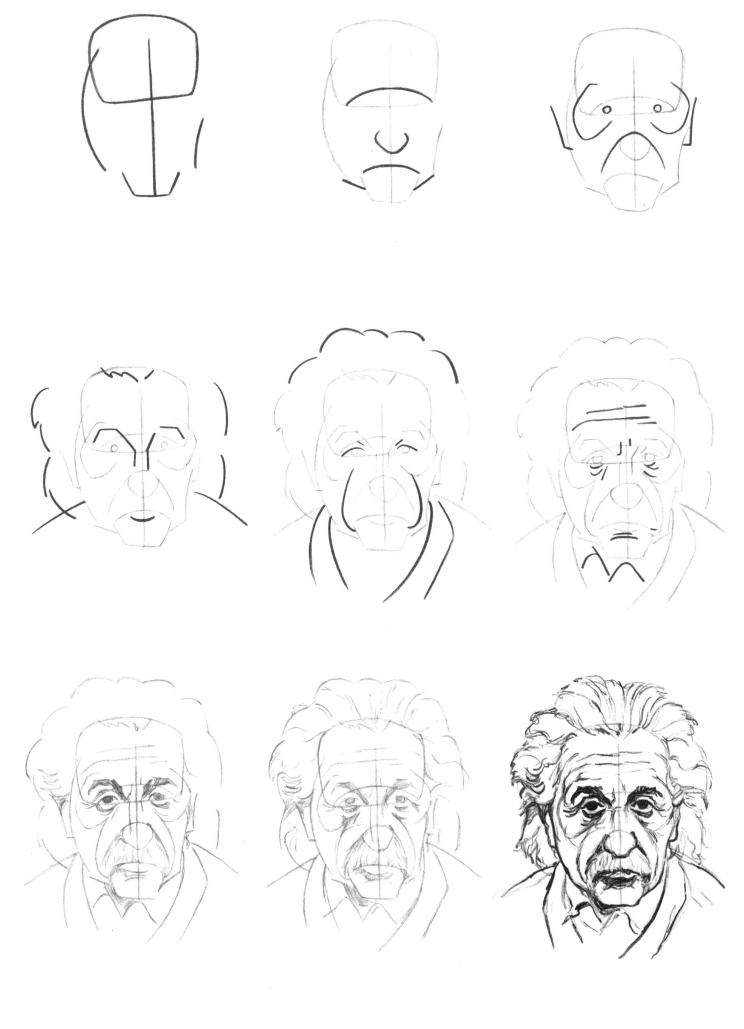

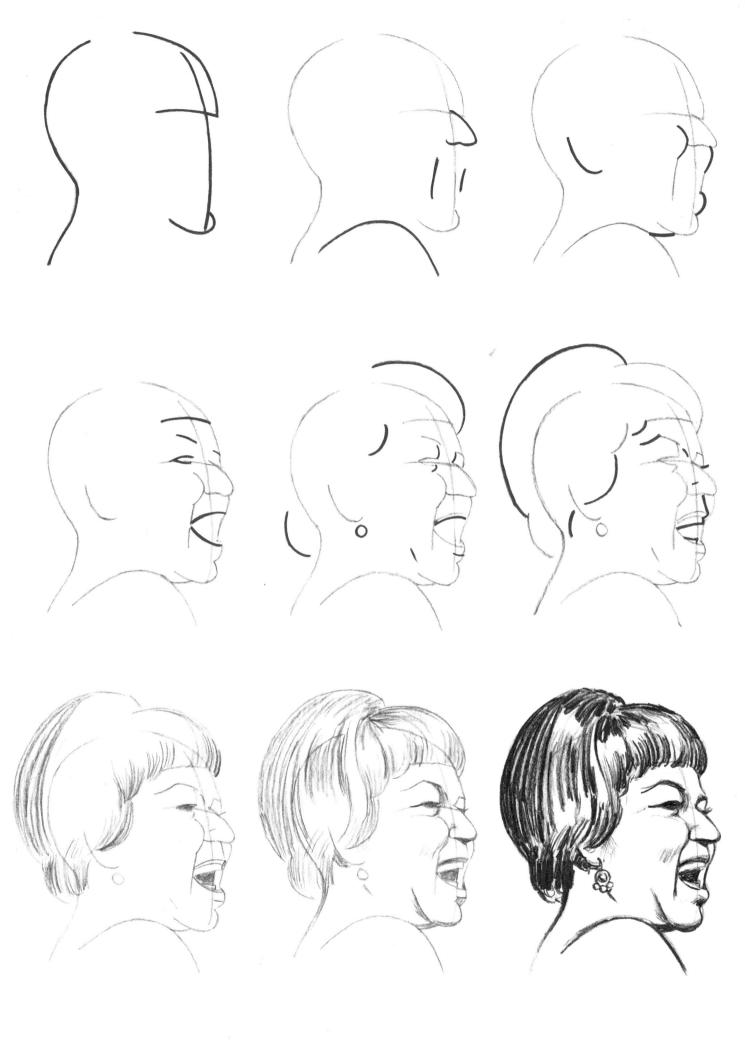

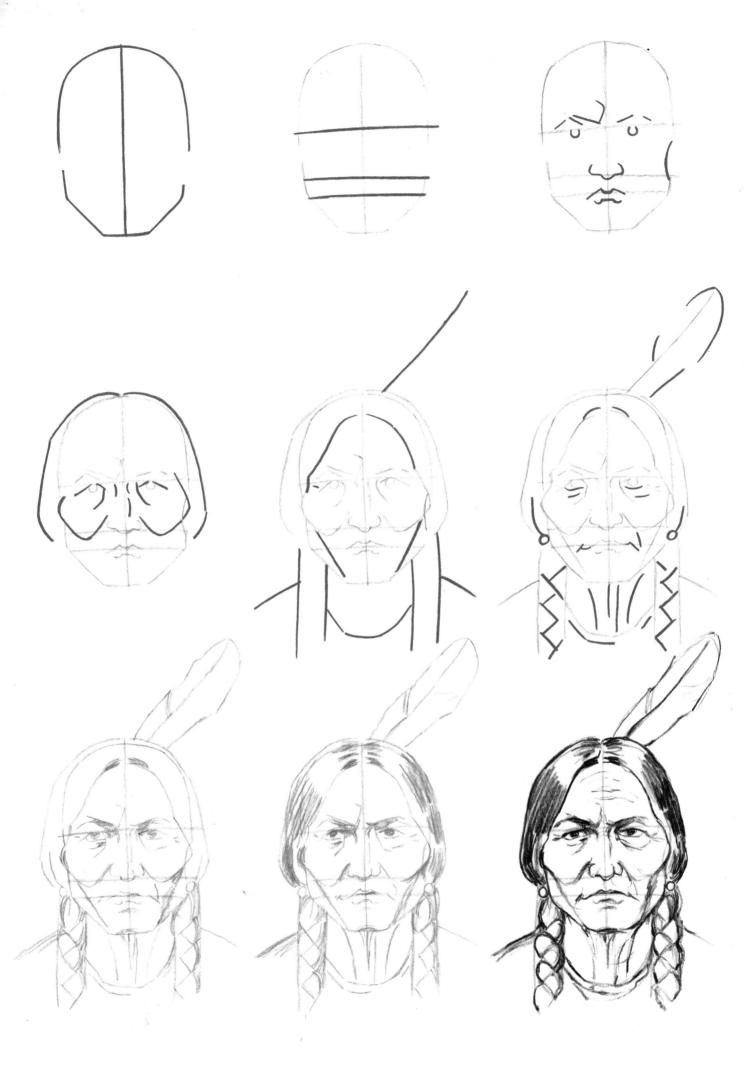

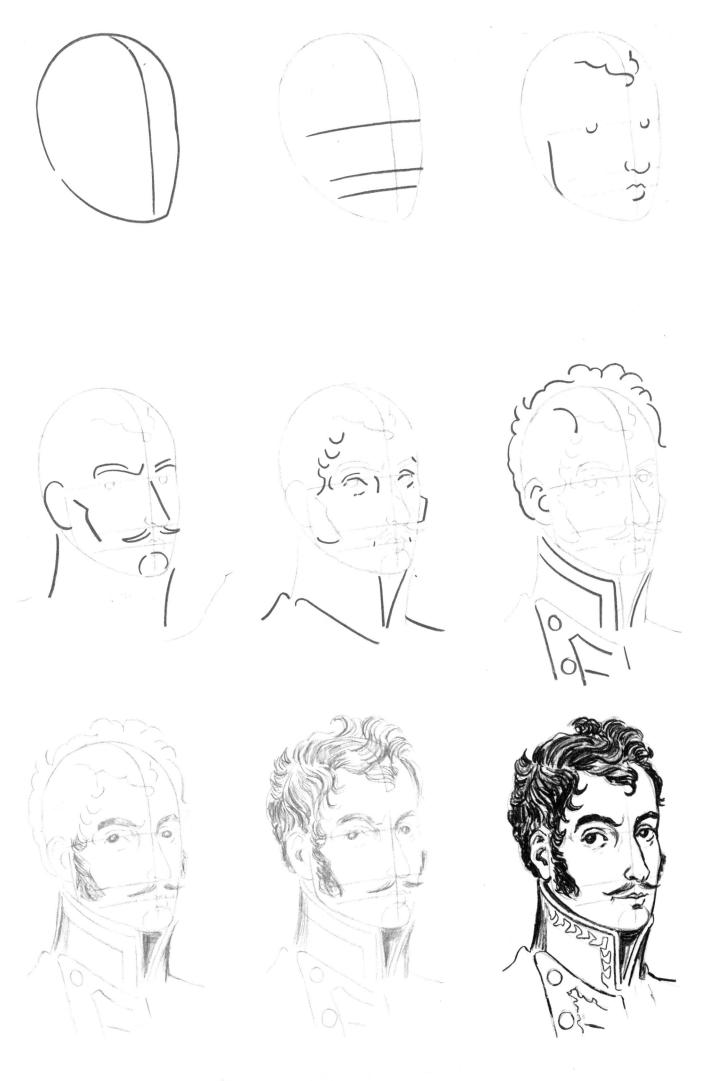

Simón Bolívar

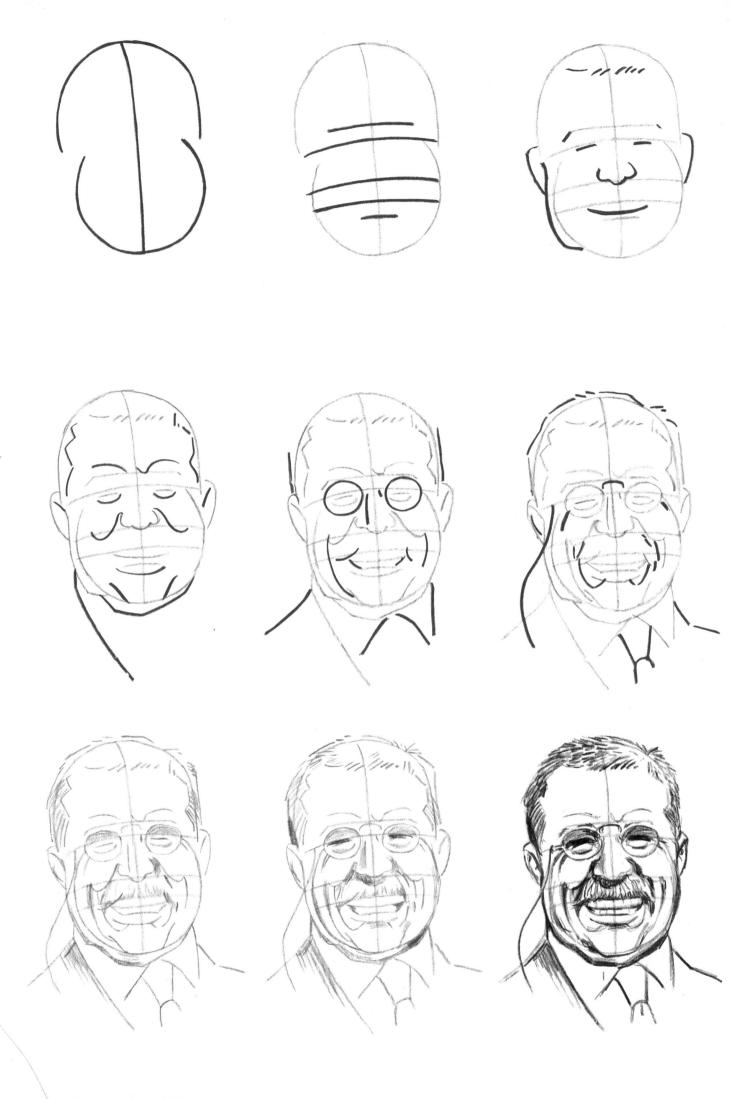

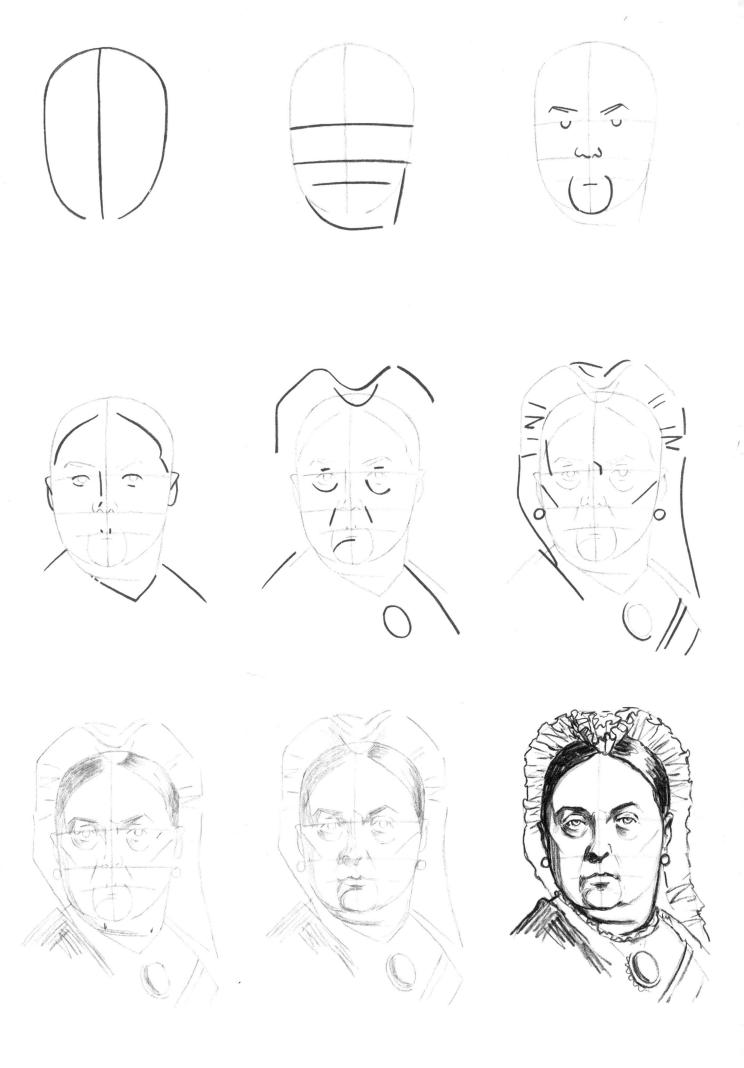

Queen Victoria

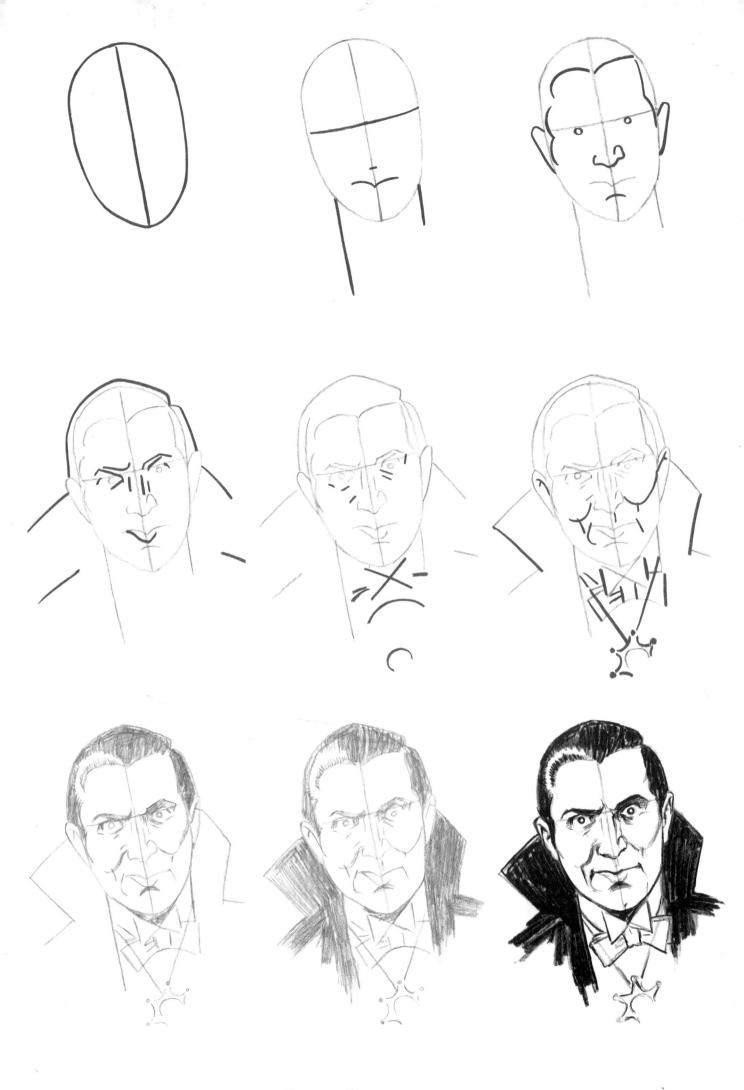

Bela Lugosi as Count Dracula

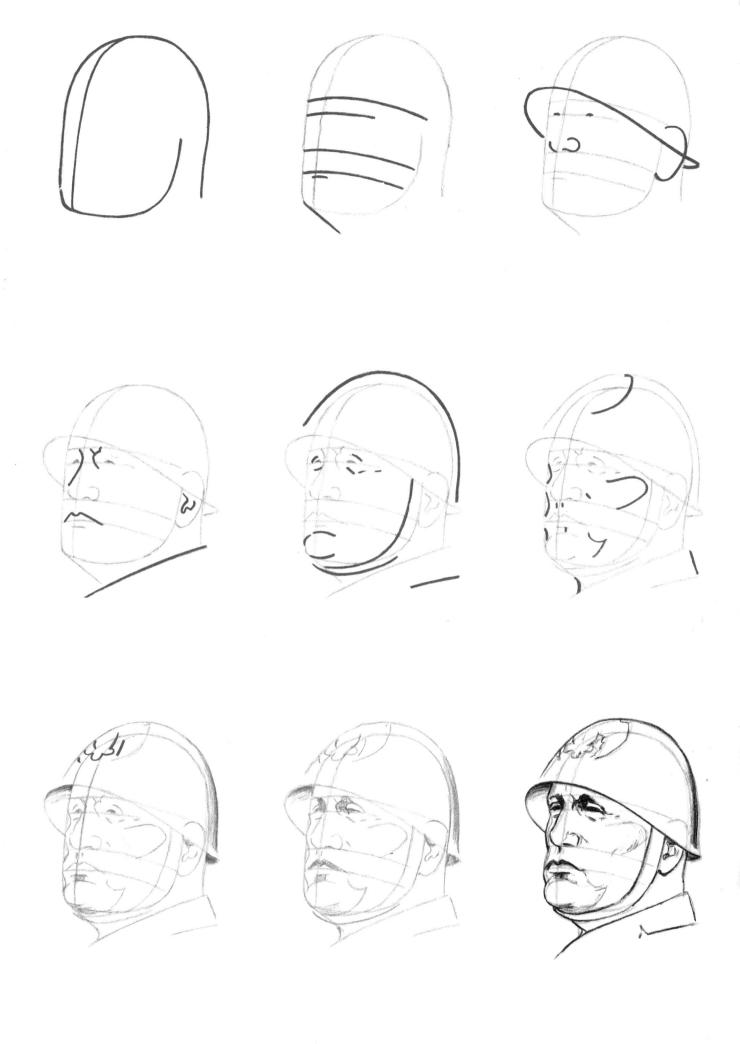

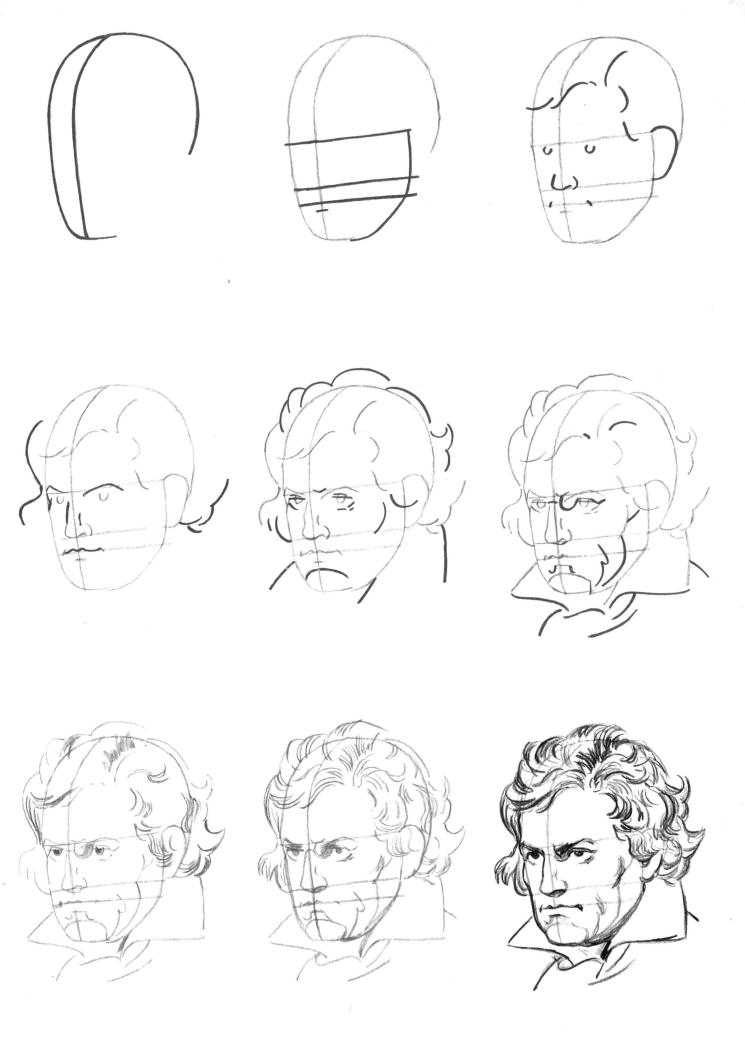

Ludwig van Beethoven

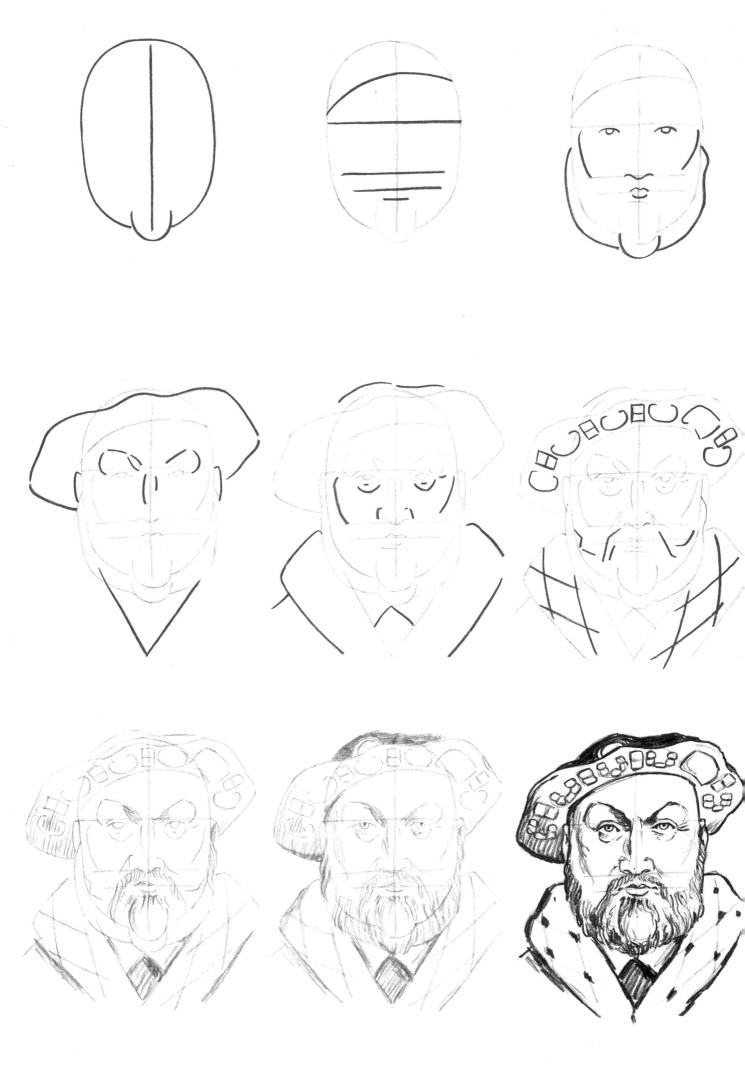

Henry VIII

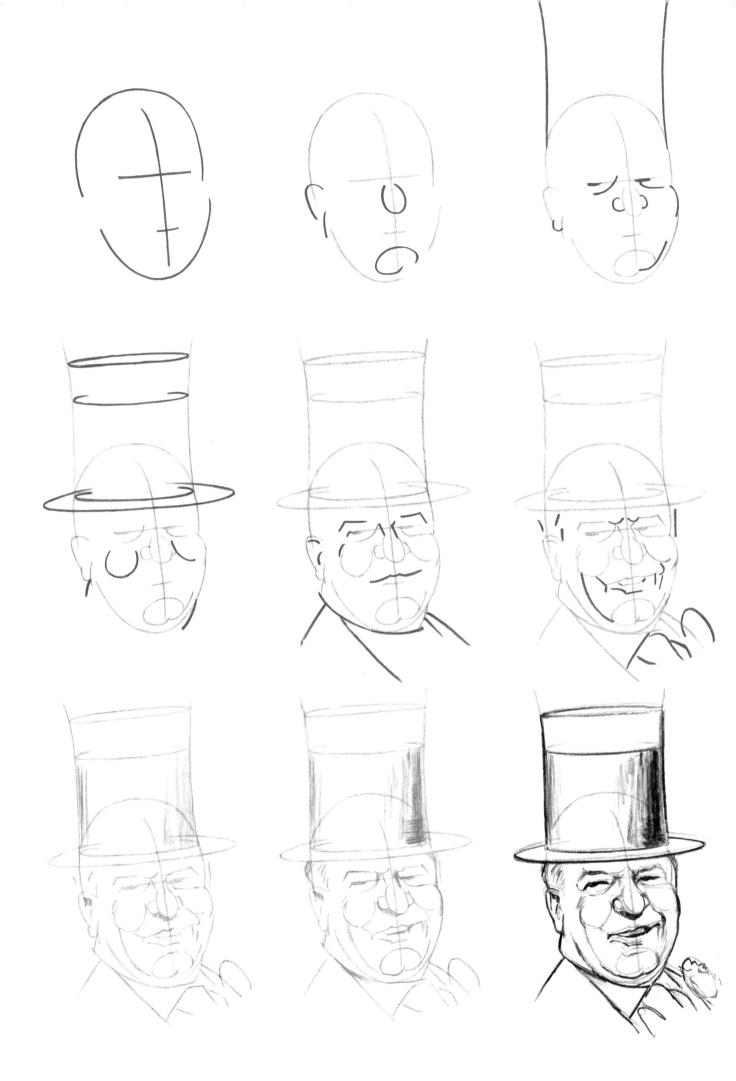

W. C. Fields

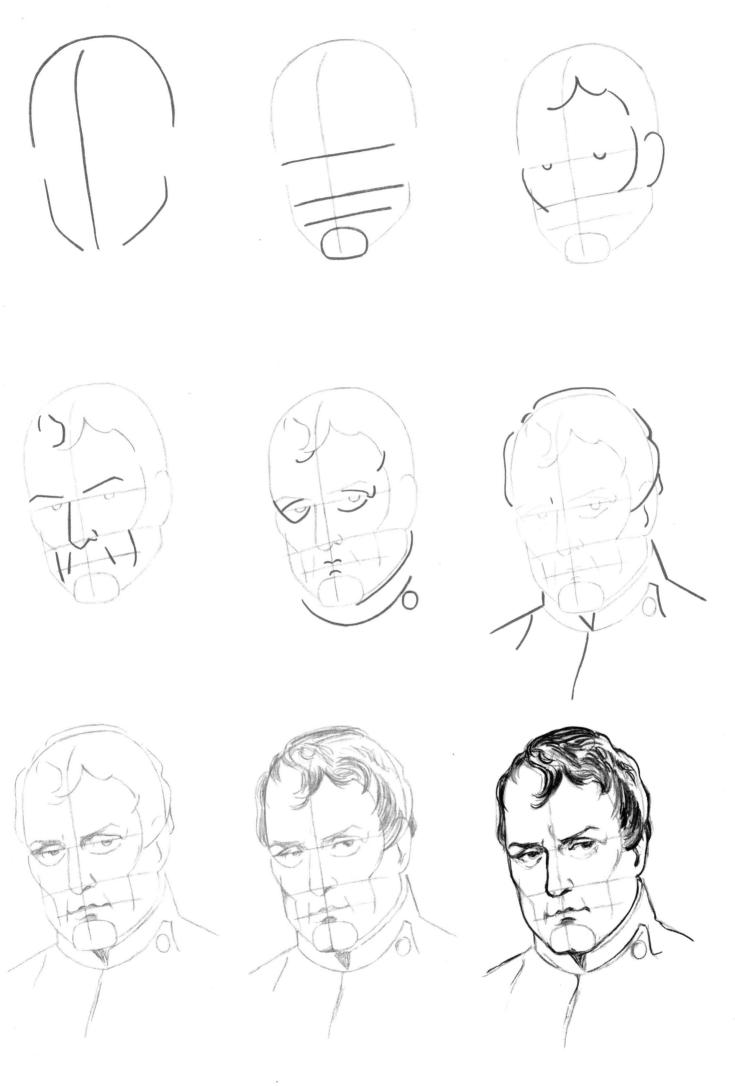

Napoleon Bonaparte

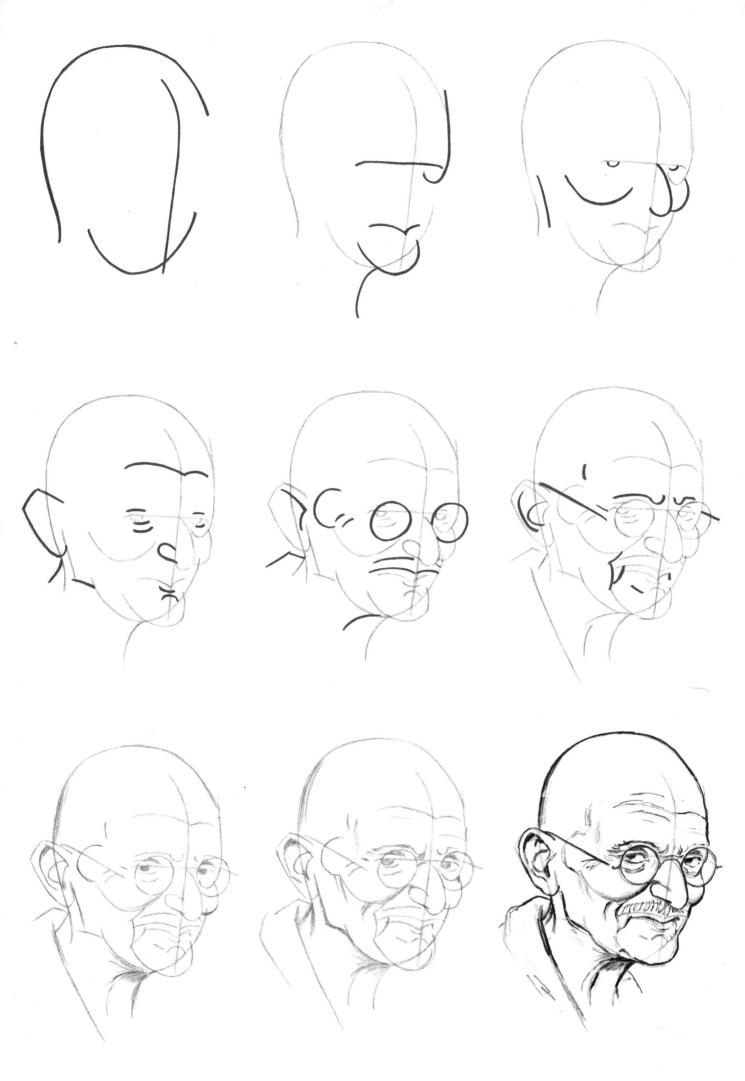

Mahatma Gandhi

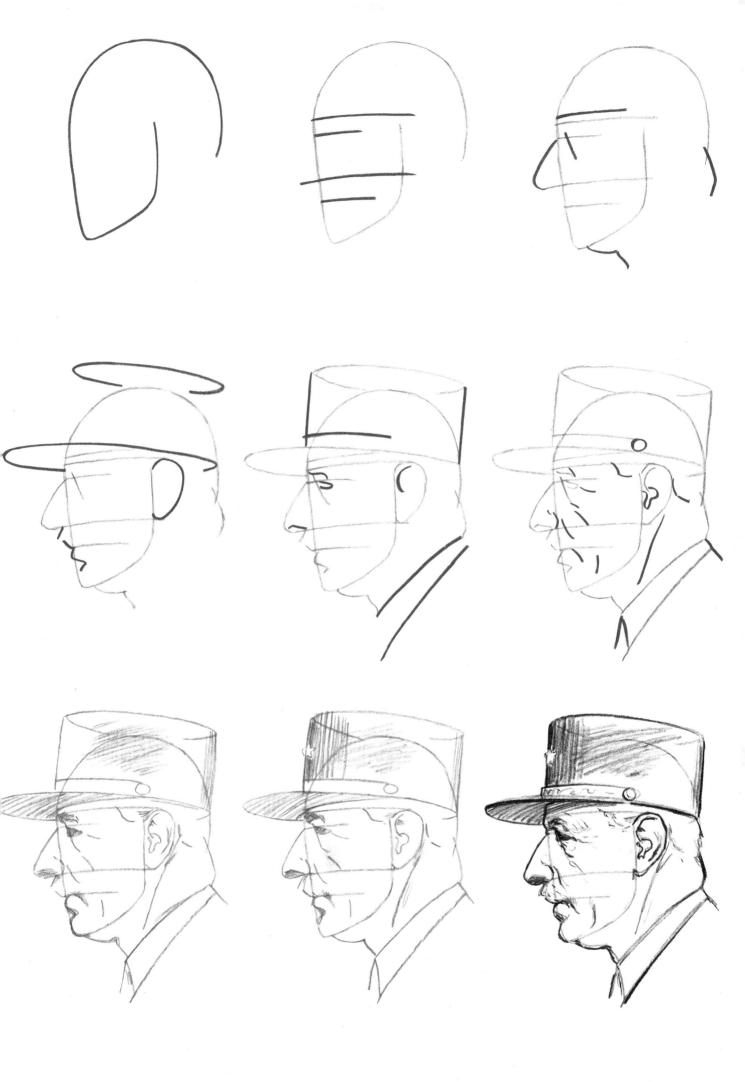

Charles de Gaulle

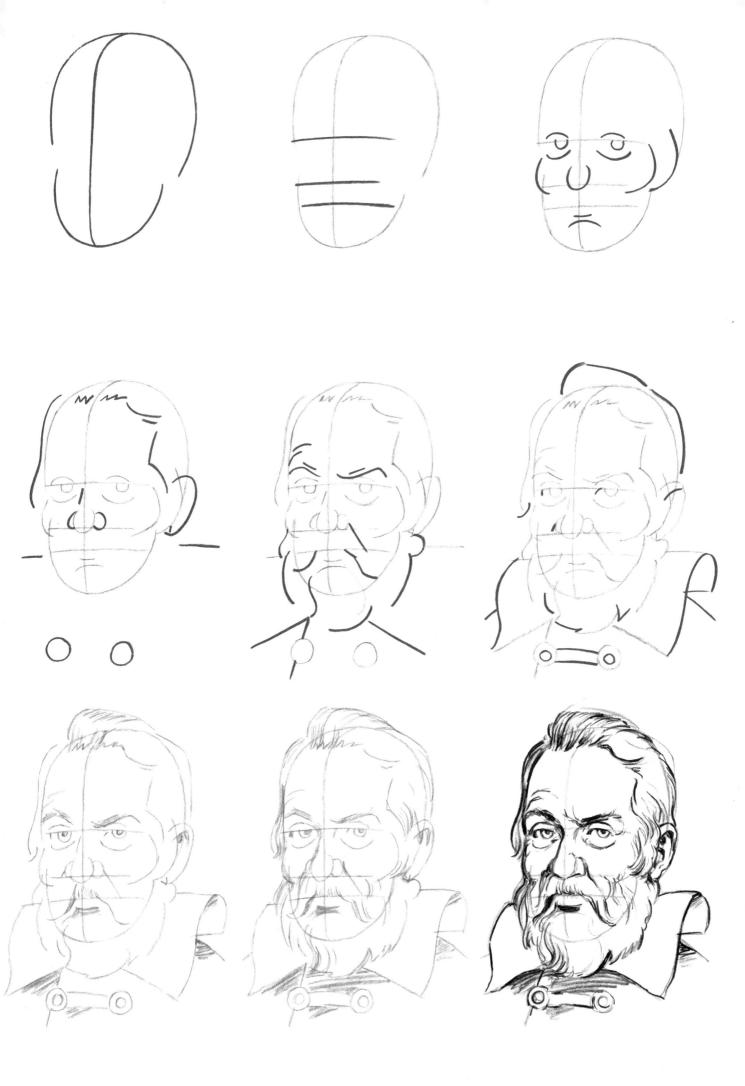

Galileo Galilei

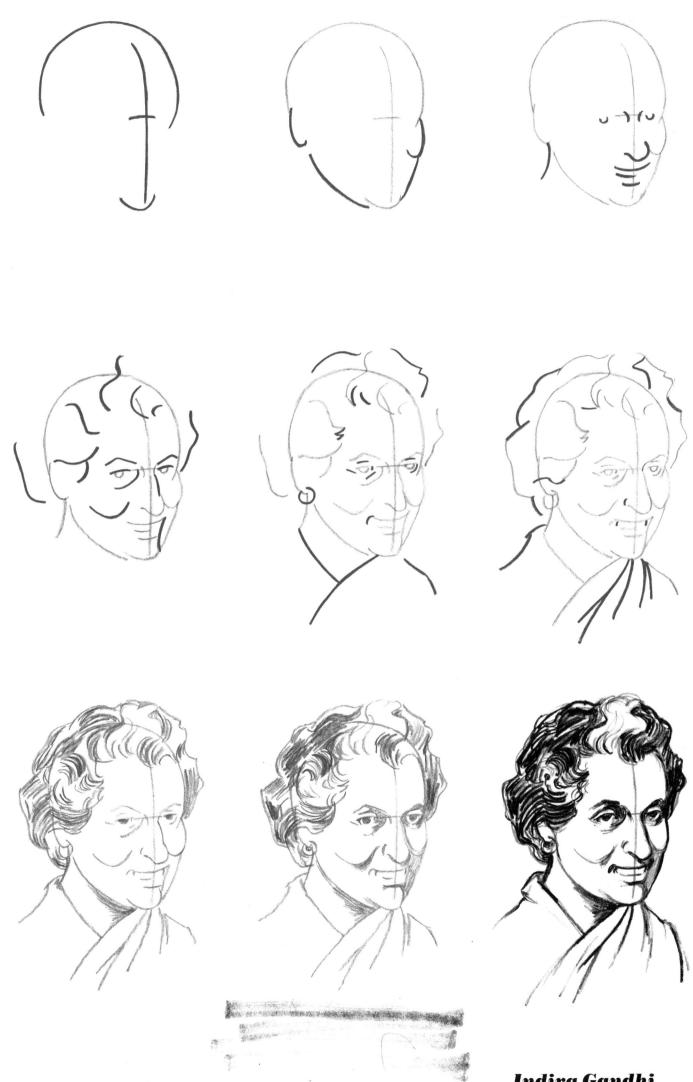

Indira Gandhi

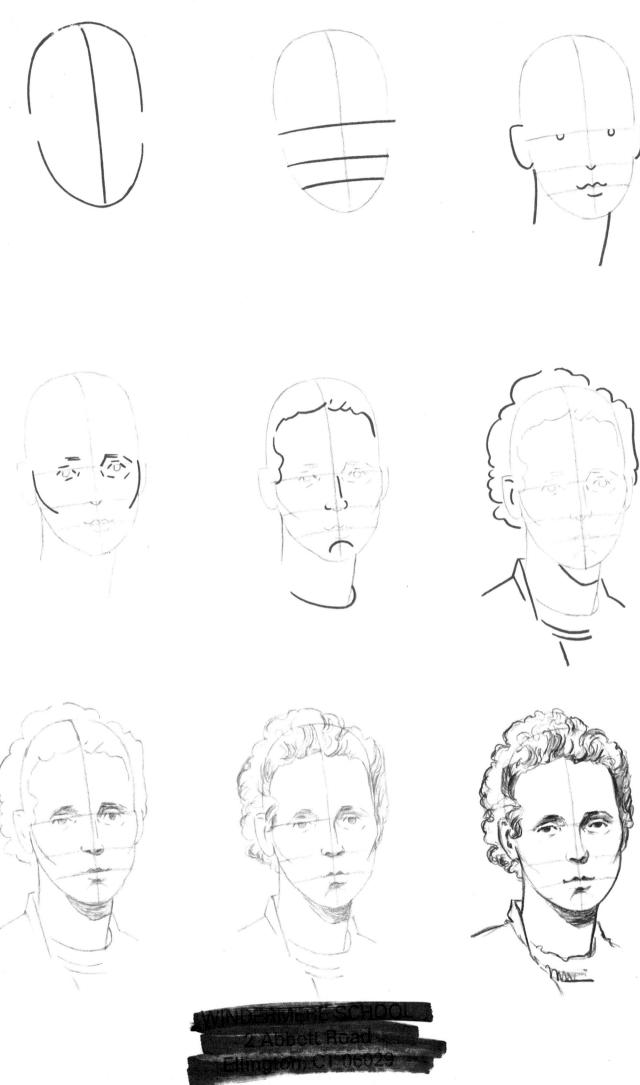

Marie Curie